A GUIDE TO VI PRESENTATION

Dr. Ruzaimi Mat Rani

Rockport Publishers
100 Cummings Center, Suite 406L
Beverly, MA 01915

rockpub.com • rockpaperink.com

10 9 8 7 6 5 4 3 2 1

ISBN: 978-1-63159-103-7

Digital edition published in 2015
eISBN: 978-1-62788-730-4

Author
Dr. Ruzaimi Mat Rani

Co-Authors
Abdul Rahman Rejab
Normadiah Kamal
Dr. Rashidi Othman

Illustrators
Dr. Ruzaimi Mat Rani
Hazwan Zai Ibrahim
Mohd Shah Irani Hasni
Elmer Sebastian Elbes
Mohd. Irwan Mohd. Ishak
Yusriza Yusof
Aidaliza Aga Mohd Jaladin

Printed in Singapore

Preface

Graphics and visual presentation are two interesting subjects that need to be explored and understood by every design student. These two subjects constitute the fundamental knowledge and basic skills that must be acquired by every design student. Design students can use graphics and visual presentation can be used as effective communication tools in design processes. We write this book in order to share our knowledge of and experiences with graphics and visual presentation techniques.

We hope the information in this book will benefit readers, especially design students from architecture, landscape architecture, interior architecture, creative multimedia and other related fields. This book contains five chapters, which cover graphics information, lines composition, sketching, design drawings and presentation drawings. We have provided many examples for students to see and comprehend. These examples include graphic images, textual information and step-by-step illustrations. The information written and illustrated in this book are the authors' suggestions and opinions based on their experiences and knowledge. We recommend our readers to look at other references and materials to strengthen their understanding of graphics and visual presentation.

Dr. Ruzaimi Mat Rani

Acknowledgement

To be able to realize my dream of publishing this book and to share my knowledge with the readers is one the greatest joys that I have in my life. Indeed, my deepest gratitude goes to all my teachers and lecturers without whom I would not be able to gain as much sketching and drawing knowledge and skills as I have today. My deepest gratitude goes to my co-authors and publisher in assisting me to complete the book contents. Also, of course, my backbone and strength, my family: Aidaliza, my beloved wife who has been with me through thick and thin in supporting me to complete this book; my adorable children, Athirah and Hazim; my much loved parents, Haji Mat Rani and Hajjah Maznah; my dear parents in-law, Haji Aga Mohd Jaladin and Hajjah Mahyah; the rest of the family members and my friends. May your unremitting support remain forever.

Good news

I have also published a blog at freedrawinglesson.blogspot.com to share my little knowledge on how to sketch, using stop motion demonstration videos (demo videos). I am looking forward to produce more than 1000 demo video to share this beautiful knowledge that has been taught by my gurus with people around the world.

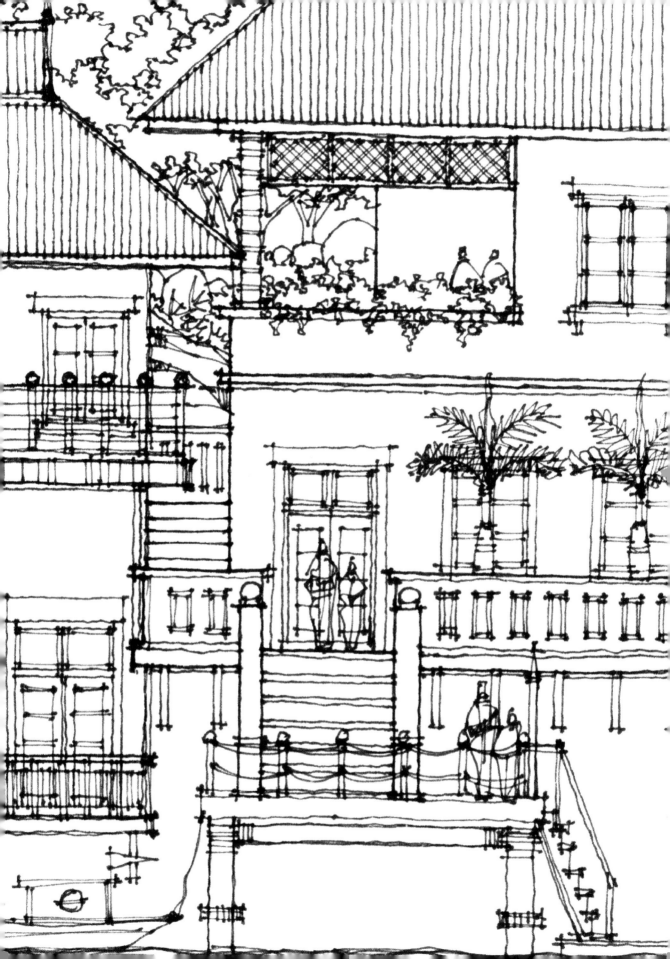

Contents

1.0 Graphics & Visual Presentation

Drawing is a fundamental tool for visualising and communicating design ideas either in two dimension or three dimensions. Drawings are formed using lines by drafting or sketching on a surface or medium. Good drawings are important to achieve an excellent visual presentation for any intended audience. Visual presentation is a broad topic involving various fields. This book focuses only on the visual designs for basic architectural drawings and sketches.

What makes good drawings for visual presentation? There are principles of good drawings that one must understand and follow to produce good graphic presentations. It is necessary to comprehend these principles in order to produce good drawings or sketches.

One must explore the opportunities that visual design can offer to produce good visual presentations. Creativity and solid drawing or sketching skills are two essential qualities that one must possess.

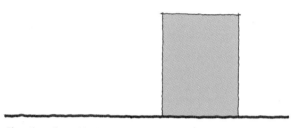

Elevation of an object

Above is an example of a two dimensional object drawn in elevation. A limited amount of visual information can be gleaned from this visual presentation. In contrast, three dimensional drawings communicate more interesting and easily understandable visual information. Below, Object A and Object B demonstrate the relative clarity and readability of three dimensional drawings. The ability to use good graphics for this visual presentation allows one to engage in effective visual communication with the audience.

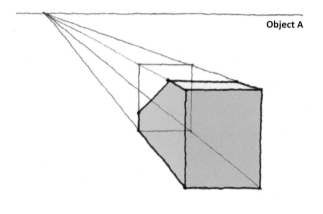

Object A

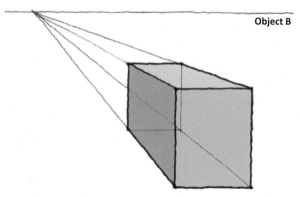

Object B

Three dimensional drawings give the visual presentation of an object clarity and readable information.

1.1 Types of visual presentation

There are two types of visual presentation you can use: manual and mechanical presentations. Manual presentations include manual drawings and sketches. On the other hand, mechanical presentations are produced using computer graphics, which include various forms of mechanical drawings and sketches. Both types of visual presentations employ the same set of visual principles to produce good visual presentations.

It is important to understand and master the fundamental principles of good visual design in order to produce excellent visual presentations. These principles involve three main components: lines, compositions, and colours.

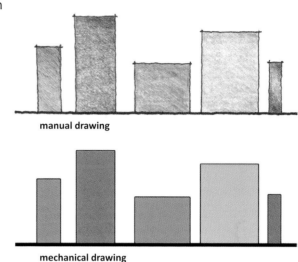

Above are examples of manual and mechanical drawings. Both types of drawings have their own characteristics, but both drawings share the same basic design principles in achieving a good visual presentation.

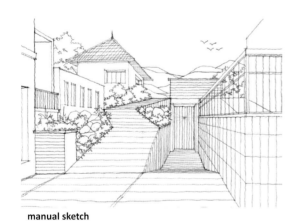

manual sketch

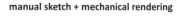

manual sketch + mechanical rendering

Explore the possibilities of achieving a good visual presentation. Remove any barriers between manual and mechanical visual presentations in your mind. One must maximise the potential these two types of visual presentation can offer.

Thin line

Thick line

elevation

Perspective

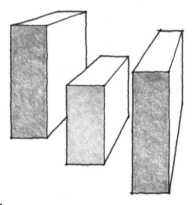

manual drawing

Manual drawing
Manual drawings are produced manually using pens or pencils on surfaces, such as papers and canvasses. Manual drawing is also known as "traditional drawing". Manual drawings can be produced using freehand or with the help of digital tablets.

Mechanical drawing
Mechanical drawings are produced using computer graphics software. There are many types of such software available on the market. These drawings are printed out using printers or plotters.

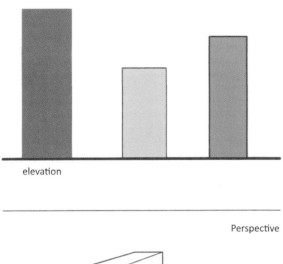

elevation

Perspective

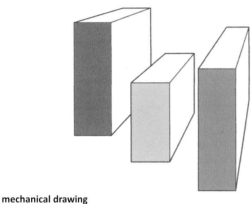

mechanical drawing

The same design principles are applied in both manual and mechanical drawing. Observe the above examples of manual and mechanical elevation drawings. Both drawings use different line weight to indicate the positions of the objects. In both drawings, the object with the thickest line is the one that appears most in front. The furthest objects in both drawings, on the other hand, are rendered using the thinnest line. The positions of these objects can be seen clearly through the perspective given. The three dimensional drawings of both manual and mechanical drawings also use the same perspective principles.

2.0 Lines

The drawing of lines constitutes one of the most important aspects of visual presentation. Lines are used in many elements of a visual presentation, such as sketches, drawings, lettering, and visual design. In order to produce good visual presentations, it is necessary to know and grasp the skills in line compositions.

2.1 About lines

A line starts with a point. A shape is a series of lines. A form derives from a shape. A composition begins with a form. These connections involving the origin of a visual presentation offer something to ponder about. A visual presentation is built on line compositions. It is thus necessary to practice the drawing of lines.

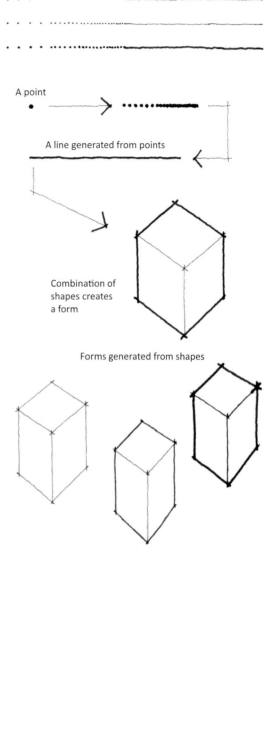

A point

A line generated from points

Combination of shapes creates a form

Forms generated from shapes

A composition generated from forms

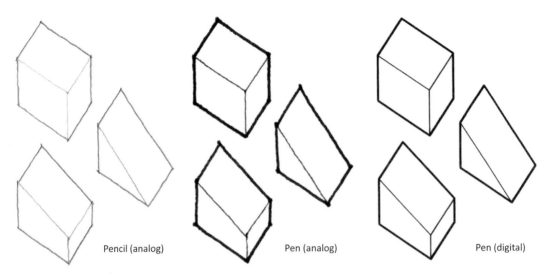

Pencil (analog) Pen (analog) Pen (digital)

Different types of media used to produce compositions

2.2 Media

Lines are produced using analogue or digital media. Examples of analogue media are pen, pencil, charcoal and art markers.

Digital media, on the other hand, refer to computer software through which lines may be created and printed out using a printer or plotter. Although different types of media can be used to produce lines, the same design principles are involved. For example, a good line composition employs lines of varying thickness and thinness.

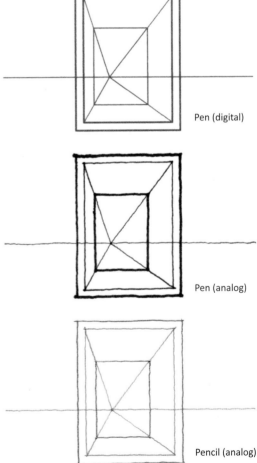

Pen (digital)

Pen (analog)

Pencil (analog)

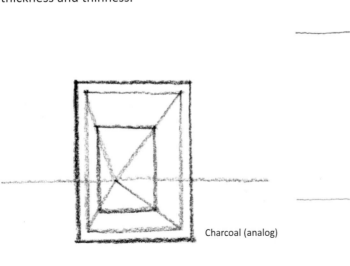

Charcoal (analog)

a. Pen Lines

Pens are classified as semi-wet media and pen lines are drawn with a range of thickness and thinness. The thickness of pen lines using both analogue and digital media begins from 0.05 cm. There are many types of analogue pens, such as felt, mechanical, and fountain pens. Understanding the function of each pen type is important in producing different compositions.

Pen: Lines generated by freehand

Pen: Lines generated by computer software

Analog drawing : A sketch generated by freehand

b. Pencil lines

Pencils belong to the category of dry media. There are two types of pencil media: graphite and wax-based. Pencil lines are defined based on the value of their tones, ranging from light to dark tones. Today, there exists computer software that can imitate the quality of pencil lines in creating a composition. It is necessary to try both analogue and digital methods of drawing pencil lines in order to find a suitable media to produce a good visual presentation.

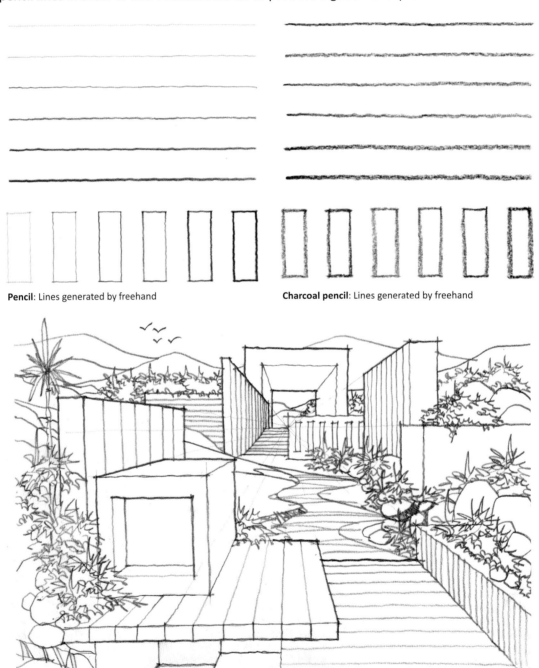

Pencil: Lines generated by freehand

Charcoal pencil: Lines generated by freehand

Pencil: A sketch generated by freehand

2.3 Drawing Lines

It is necessary to have well-drawn lines in a composition. Many types of lines can be employed in a composition. The most important part of forming a composition is the accuracy of line formations. Observe the examples given, and identify the mistakes you must avoid.

One must ensure that the lines are joined properly in order to avoid incomplete object composition as shown in the three examples given.

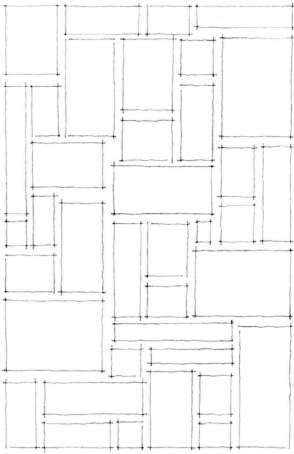

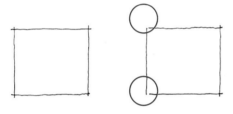

This composition with red circles is incomplete compared to the composition on its left because the lines of the former are not joining.

How many rectangles are in the composition given?

 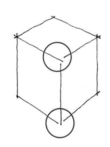

The lines of an incomplete three-dimensional composition are not joined, thus this composition cannot be called a box.

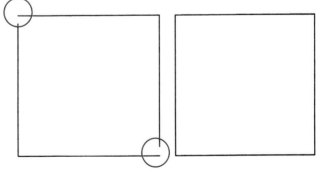

The above composition with red circles cannot be called a square because it is an incomplete composition. Incomplete compositions can also result from using computer software.

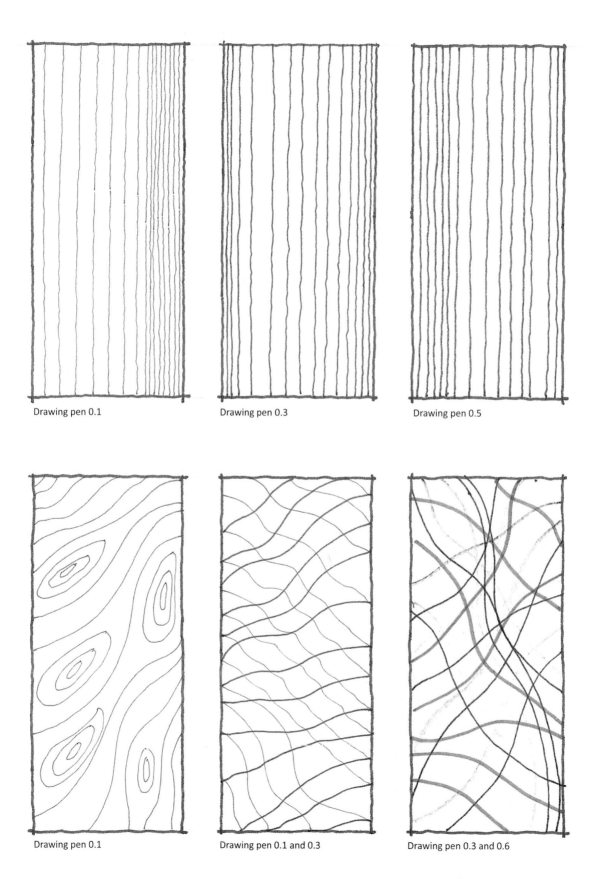

Drawing pen 0.1

Drawing pen 0.3

Drawing pen 0.5

Drawing pen 0.1

Drawing pen 0.1 and 0.3

Drawing pen 0.3 and 0.6

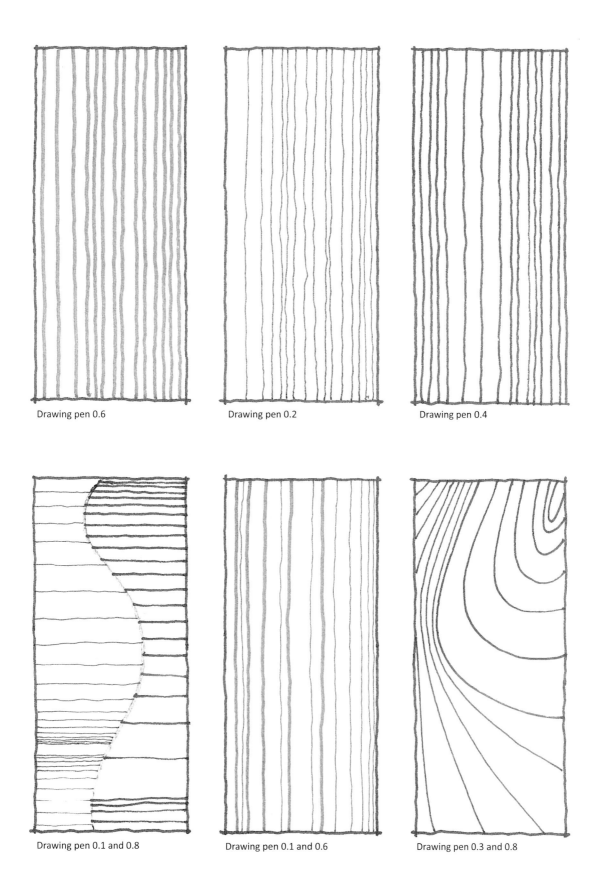

Drawing pen 0.6

Drawing pen 0.2

Drawing pen 0.4

Drawing pen 0.1 and 0.8

Drawing pen 0.1 and 0.6

Drawing pen 0.3 and 0.8

19

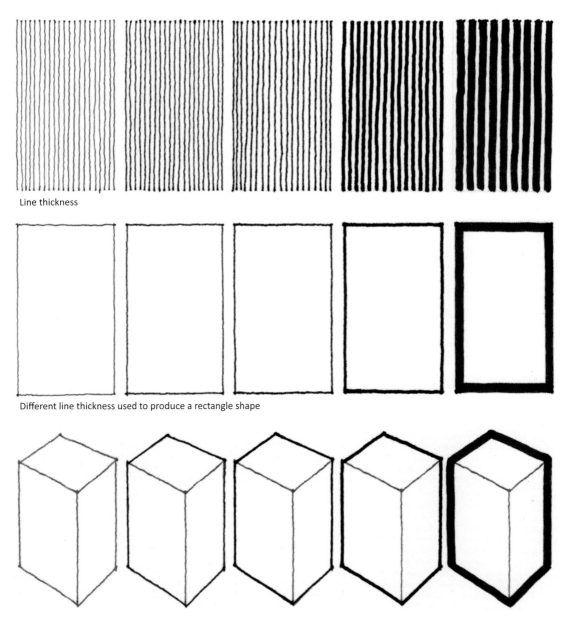

Line thickness

Different line thickness used to produce a rectangle shape

Different lines thickness used to produce a box

Line Weight & Composition

An excellent line visual composition is built on good line compositions. You must be able to understand and be skilful in employing different line thicknesses in your compositions. Various line thickness have a different impact on a composition, as shown in the above examples of two and three dimensional compositions. A rectangle drawn using a thick line stands out compared to rectangles using a relatively thinner line. In the three dimensional composition, a box using a thin line looks much flatter compared to boxes using thicker lines. So, thick outlines make a box stand out. You should therefore be careful when choosing the thickness of lines in producing a composition.

Case study 1: Line & Compositions

A good composition contributes to a good visual presentation, thus compositions of lines should be drawn properly. Observe the examples below. Compositions 1 and 2 have a negative visual impact because one of their rectangles is not drawn or sketched accurately. The quality of both compositions thus decreases and the overall visual presentation fails to deliver.

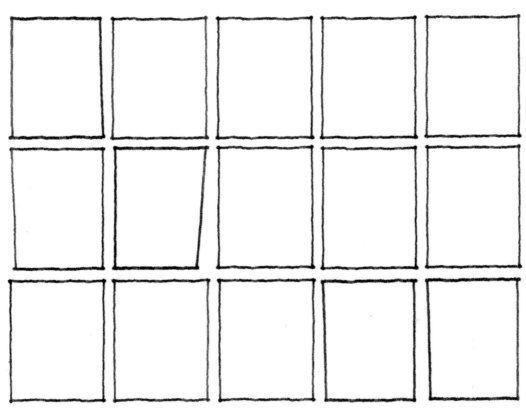

Composition 1: One of the rectangles is not drawn properly

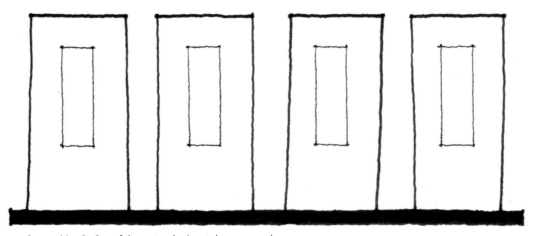

Composition 2 : One of the rectangles is not drawn properly

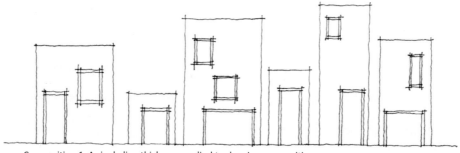

Composition 1: A single line thickness applied to drawing composition.

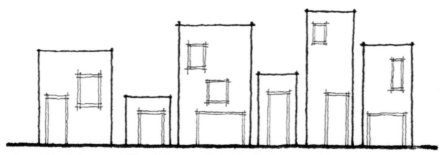

Composition 2: Two types of line thickness applied to the drawing composition

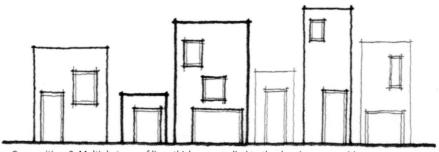

Composition 3: Multiple types of lines thickness applied to the drawing composition

Case study 2: Lines & Compositions

Line thickness is very important in creating good compositions. The principle here is to employ line hierarchy in order to accurately communicate the visual position of each object in a composition. This principle can be applied to different drawings, such as plans, sections, and elevations. Observe the three examples above. Different types of lines are employed in each composition. Although the three compositions above use the same template, their visual presentations change once a different line type is used. In Compositions 1 and 2, the objects drawn are aligned with each other and the objects appear so because the objects' outlines are rendered using lines of the same thickness. In Composition 3, different line types have been used and the objects that appear most in front can be identified by their thicker lines.

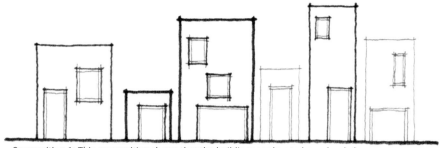

Composition 1: This composition shows that the buildings are located on a level plane.

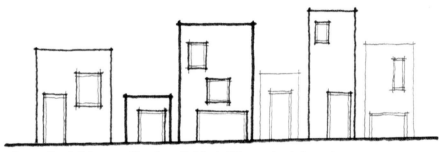

Composition 2: This composition shows that the buildings are located up a slope.

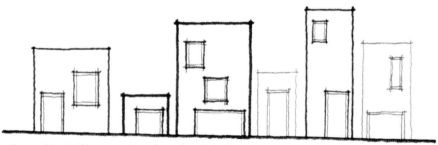

Composition 3: This composition shows that the buildings are located down a slope.

Case study 3: Lines & Compositions

Lines are very important to a composition. Any line that you draw or sketch contributes to the overall visual impact of your composition. Lines should be carefully drawn with the proper angles or in the desired position in order to avoid any negative visual impact. Observe the three examples above. Each of the compositions has a different visual impact because of its different plane angles. Each of the compositions therefore communicate different meanings and indicates varying characters.

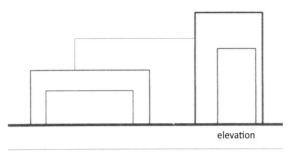

elevation

Different line thickness are used for object compositions

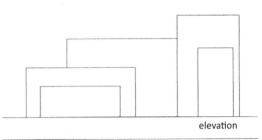

elevation

Single thinner lines are used for object compositions

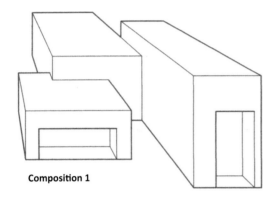

Composition 1

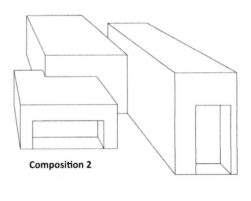

Composition 2

Case study 4: Lines & Compositions

One must explore the potential in employing different line thickness in a composition. Line thickness helps to highlight 'depth' which creates the characters of a drawing composition. For example, varying thicknesses convey differing senses of depth or distance that in turn create front and middle planes, as well as backgrounds. Observe the compositions given. The visual impact of each composition is different because of the use of different line thicknesses. Composition 1 demonstrates an excellent composition that takes full advantage of different line thicknesses. This highlights the visual presentation quality of the drawings in Composition 1.

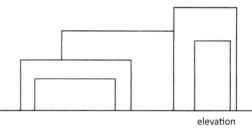

elevation

Single thicker lines are used to compose the object compositions

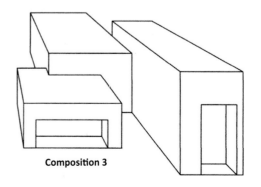

Composition 3

Case study 5: Lines & Compositions

It is important to apply line thickness in a perspective composition
n to give a sense of 'depth' or the illusion of three dimensions. Multiple line thicknesses in
a composition create a unique mood that contributes to the composition's visual impact.
Compare the examples given. In Example 1, it is clear that a perspective composition using a
single line thickness is less attractive than Example 2, in which multiple line thicknesses are
used. Example 2 thus appears visually more interesting.

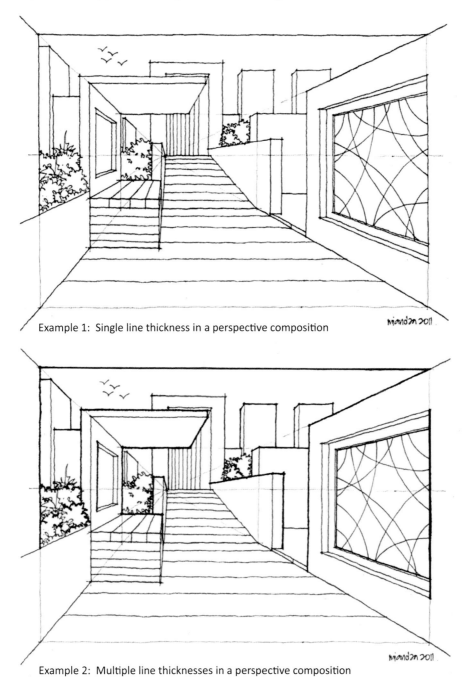

Example 1: Single line thickness in a perspective composition

Example 2: Multiple line thicknesses in a perspective composition

Composition 1: Different types of pencil lines in a perspective setting

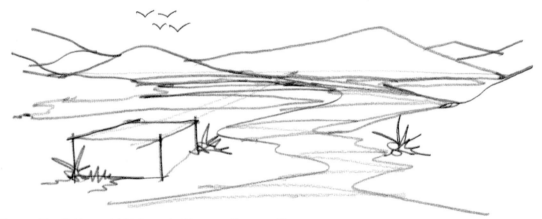

Composition 2: Line weight is important in a pencil composition

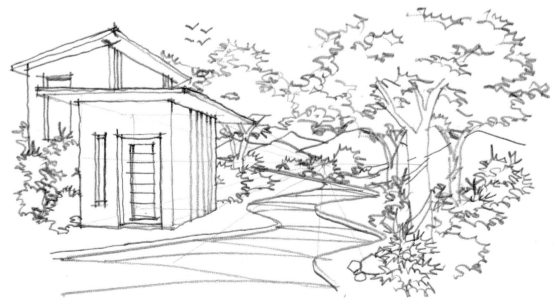

Composition 3: Different pencil lines can create an interesting composition

2.4 Line types

There are many line types that can be produced using either pens or pencils. Each of these line types has its own character and way of usage. Some of the line types can be found in many surfaces and objects around us. For example, straight lines are used to draw objects such as squares, rectangles, and boxes. Curved lines, on the other hand, can be used to draw objects with curved, convex, or concave surfaces. Lines are also used in diagrams and maps.

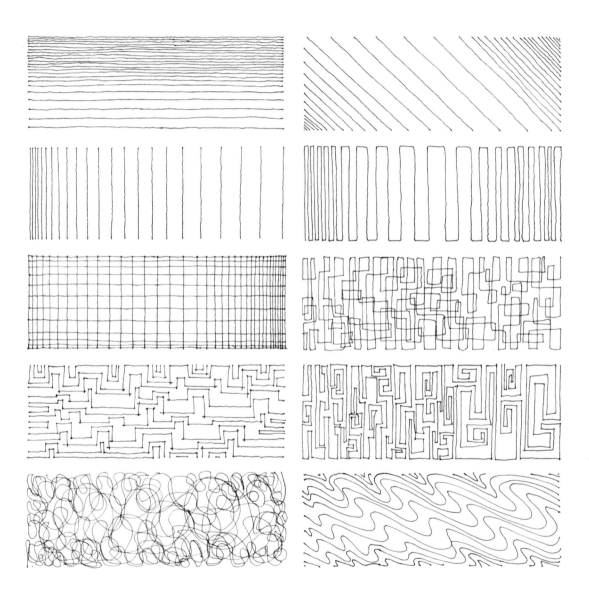

2.5 Lines and Patterns

Patterns can be found everywhere on object surfaces, such as tabletops, walls, glasses, and metals. Different patterns can be produced using different types of lines. Creativity and the ability to draw and sketch good lines are keys to creating interesting pattern compositions. Below are some examples of patterns that can be found around us.

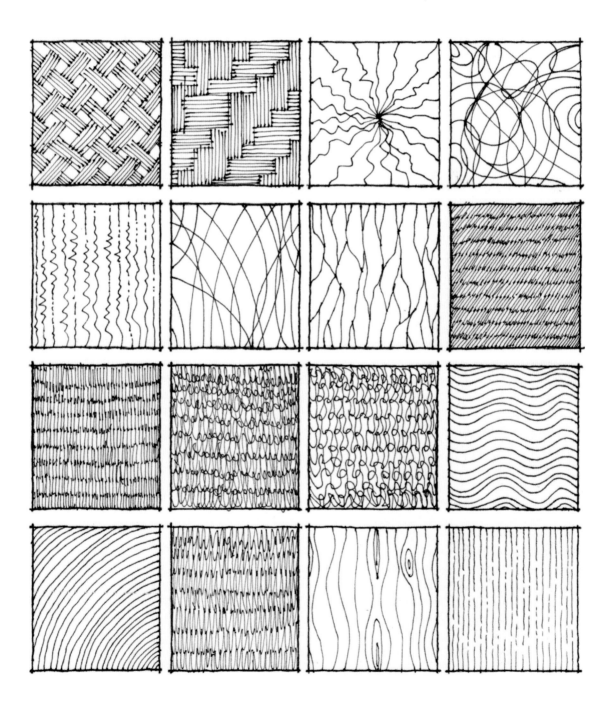

Wonders can be created with lines. You need a proper knowledge of lines in order to create interesting pattern compositions. Observe the examples below. They show how patterns can be created from different types of lines. Each pattern possesses its own visual character. Some are formal and informal, while others are random, wavy, and grid-like. These visual characters enhance the composition of objects or surfaces in a visual presentation.

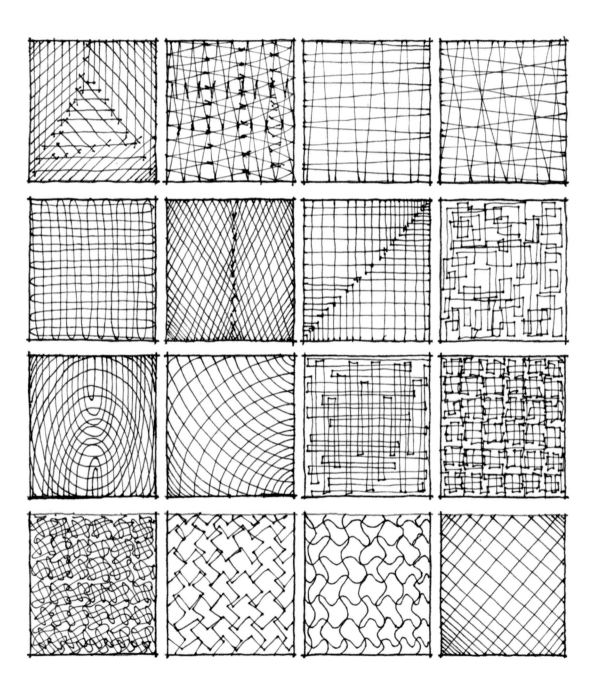

Interesting patterns can also be found in building materials.
Observe the examples below. Lines are drawn to produce different
formations that are found in building materials.

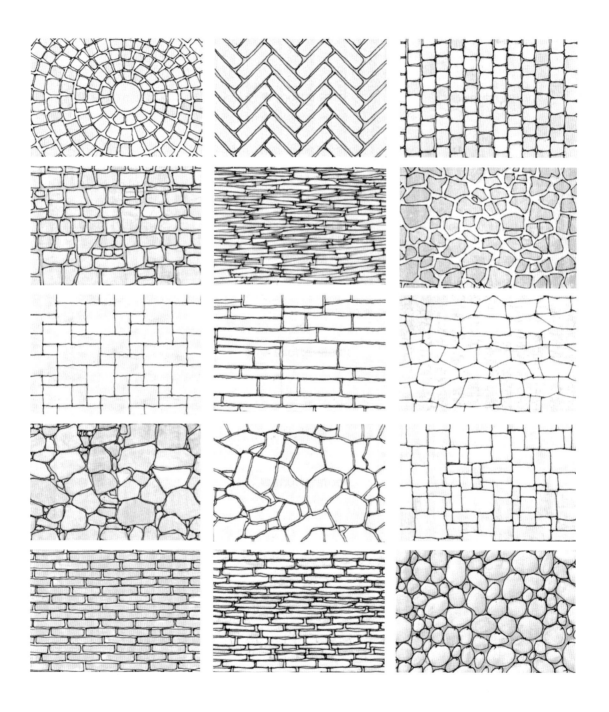

2.6 Lines and Forms

A form can be composed in two or three dimensional drawings using many different types of lines. A sound knowledge of the skills involved in composing lines is essential in creating simple or complex forms. It is also important to draw or sketch accurate lines to produce an excellent composition.

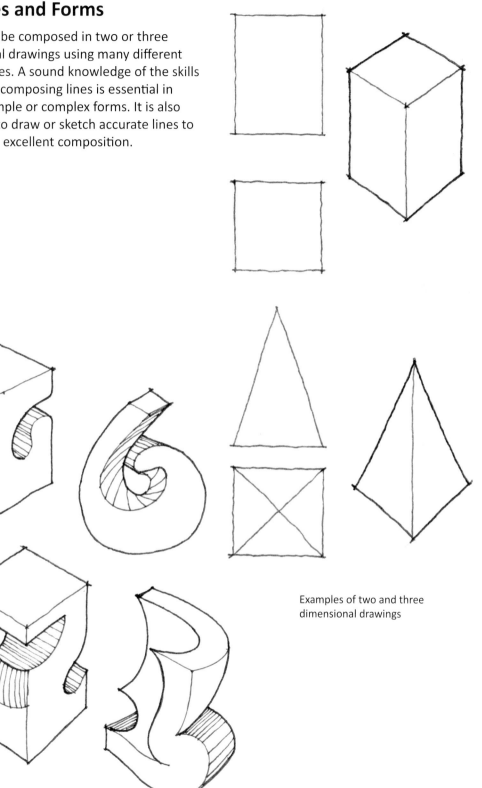

Examples of two and three dimensional drawings

Lines can produce excellent two dimensional drawing compositions. Take, for example, the blank surface of a mug. By using different types of lines, we can create many patterns that define the surface of the mug. For instance, different types of glass surfaces can be created. You need to be creative in using various lines to produce a good rendering pattern that defines the object surfaces in a composition. Below is an example of a good exercise you can use in composing and practising the drawing of various lines.

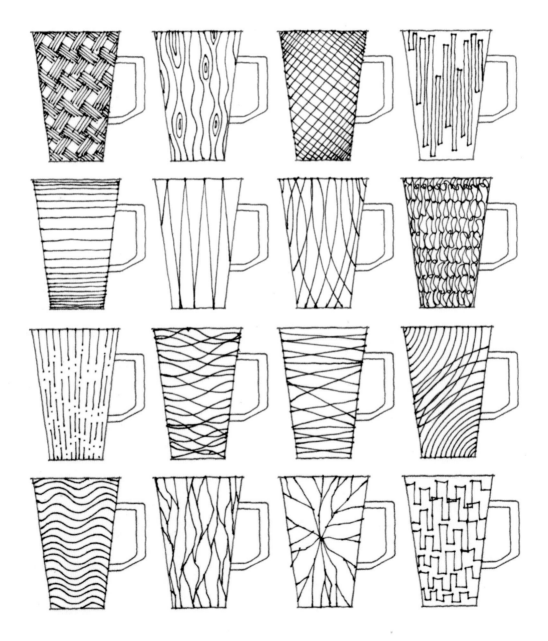

These are other examples of lines in a two dimensional object composition. Each of the patterns drawn on the surface of the door gives an interesting visual character and identity to the door. The different patterns indicate various building materials that construct the door. The ability to select proper lines and patterns and apply them to relevant surfaces will enable you to produce good two dimensional visual presentations.

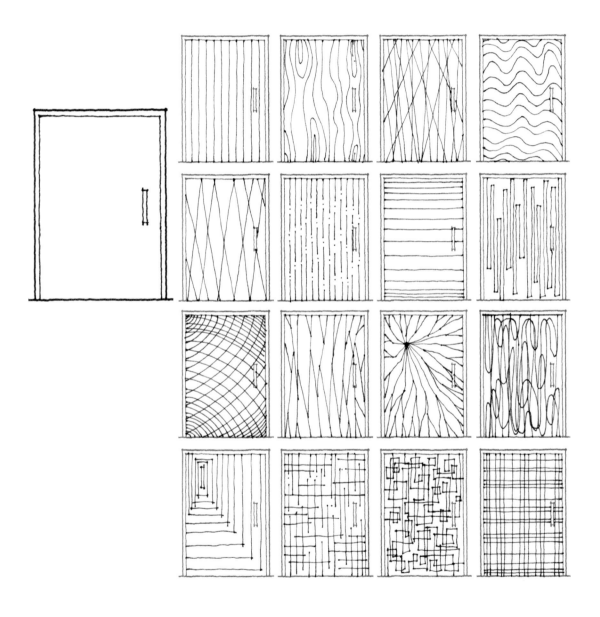

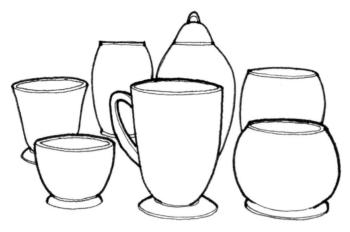

Different types of lines are used to render the surfaces of the objects, creating Interesting patterns on the objects. Observe, for example, the glass surfaces in Compositions 1 and 2, which use similar curvy lines but positioned at different angles. The result is the creation of different surfaces and visual characters which give different meanings and ambience to the objects.

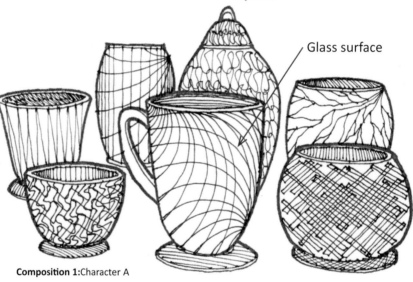

Glass surface

Composition 1:Character A

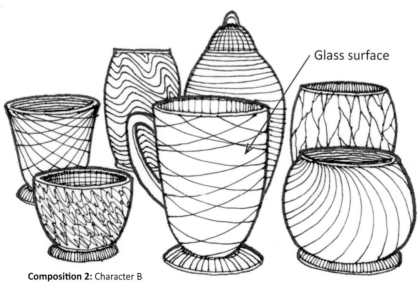

Glass surface

Composition 2: Character B

Perspective is one of the techniques you can use to visualise a space ambience. Many types of lines can be used to highlight the ambience of the space. Do observe the three examples given. They clearly visualize three different space ambiences produced by rendering different types of lines on object surfaces.

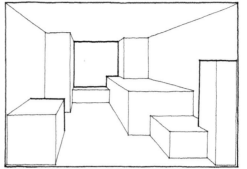

A room without any of the objects' surfaces rendered

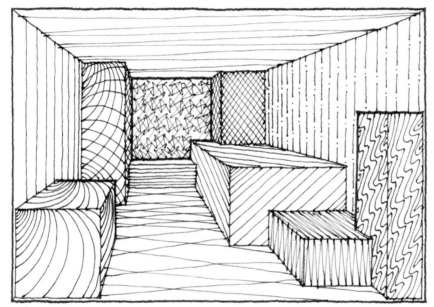

Space 1, Character 1:
The same room above with surfaces rendered

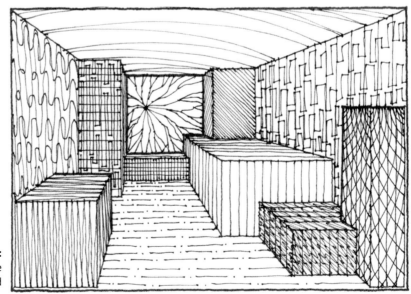

Space 2, Character 2:
The same room above with surfaces rendered

A combination of lines can also be used to create interesting textures that give buildings character. In Examples 1 and 2 below, combining many types of lines create two sets of building characters.

Facades without characters

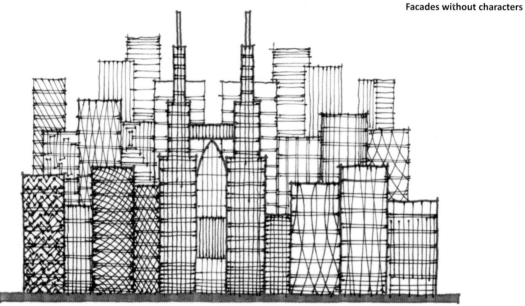

Example 1: Facades with characters

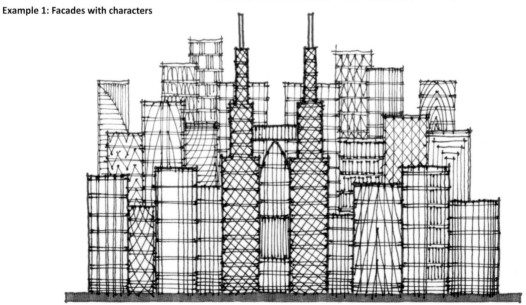

Example 2: Facades with characters

2.7 Lines and lettering

Letterings are formed using different types of lines. These are some examples of letterings created from specific lines. Each example has its own character and identity, conveying a range of formal and informal qualities.

ABCDEFGHIJKLMN
OPQRSTUVWXYZ

abcdefghijklmno

pqrstuvwxyz

Lines in lettering 1

ABCDEFGHIJKLMN
OPQRSTUVWXYZ

abcdefghijklmnop

qrstuvwxyz

Lines in lettering 2

ABCDEFGHIJKL
MNOPQRSTUV
WXYZ

abcdefghIjklm
nopqrstuvwxyz

Lines in lettering 3

Lines in lettering 4

37

ABCDEFG
abcdefghij
HIJKLMN
klmnopqrst
OPQRSTU
uvwxyz.ab

ABCDEFGHIJKLMNOPQRSTUVWXYZ

Lines in lettering 5

ABCDEFG
HIJKLMN
OPQRSTU
VXYZAB
CDEEFGHI
JKLMNO
PQRSTU....

HOPE

Lines in lettering 6

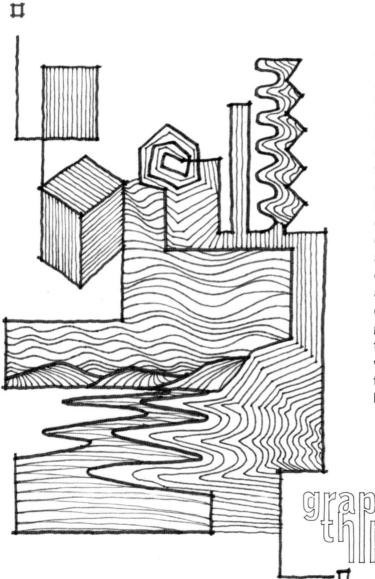

2.8 Lines and Graphics

A line is a basic component of graphics. Lines are used to shape and form interesting graphics. What are graphics? Graphics refer to any pictorial information or visual presentation that is produced using lines, colours, textures and other elements. Graphics are used as a medium to communicate a subject or an idea. Wonders can be done with lines to produce good visual graphics. On the left is an example of a visual presentation using a few line types and different kinds of line weight.

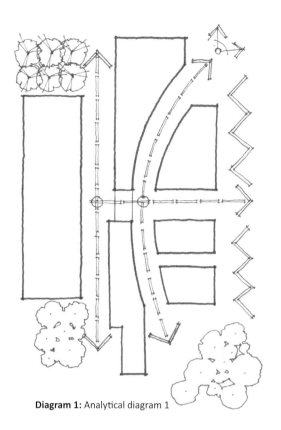

Diagram 1: Analytical diagram 1

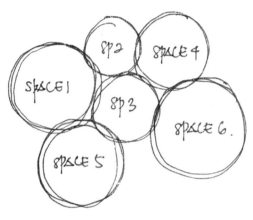

Diagram 2: Bubble diagram

2.9 Lines & Design Drawings

There are many types of drawings: diagrams, plans, sections, elevations, isometrics and more. These drawings are created using different types of lines and line thickness. Observe the examples given. Diagrams can be produced using a range of line thicknesses, from single to multiple thicknesses, depending on your intentions.

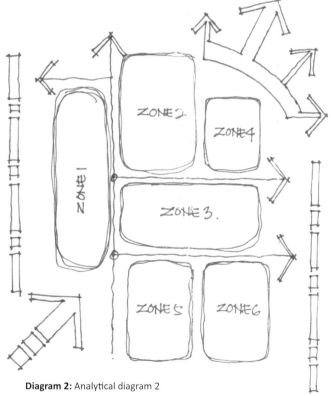

Diagram 2: Analytical diagram 2

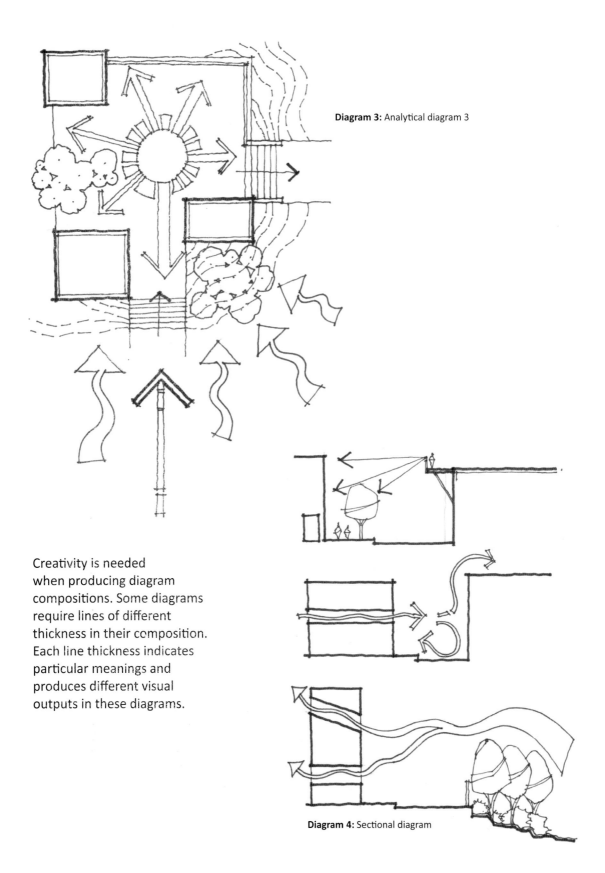

Diagram 3: Analytical diagram 3

Creativity is needed when producing diagram compositions. Some diagrams require lines of different thickness in their composition. Each line thickness indicates particular meanings and produces different visual outputs in these diagrams.

Diagram 4: Sectional diagram

Building drawing: Section

Building drawing: Elevation

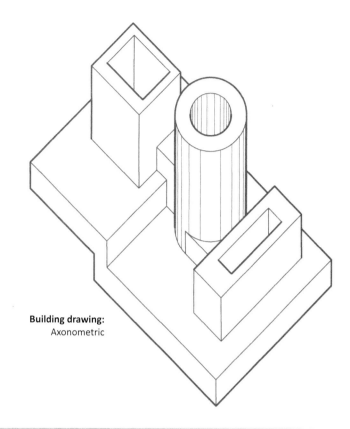

Building drawing: Axonometric

Building drawings: There are many types of lines involved in creating a building drawing. Observe the examples given. They range from presentation to technical drawings. Compare these examples and identify some of the interesting visual impacts created by different line thickness. Each of them has their own purpose and function in making the drawing composition look good and interesting.

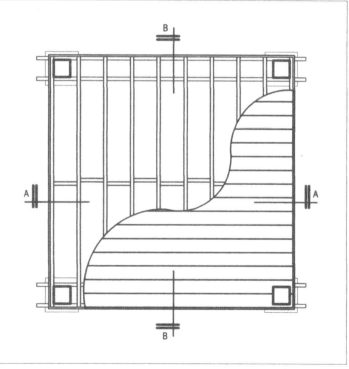

Building drawing: Plan

Line thickness plays a very important role in drawing compositions. Do observe the two examples given. Which one is better? Composition 1 uses single line thickness while Composition 2 uses multiple lines thicknesses. The multiple lines thicknesses used in Composition 2 gives 'depth' to the drawing composition.

Composition 1 : Single line thickness drawing compositions

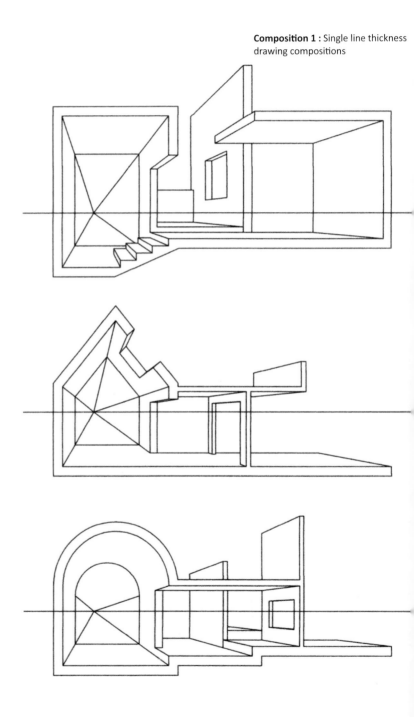

Composition 2 : Multiple line thickness drawing compositions

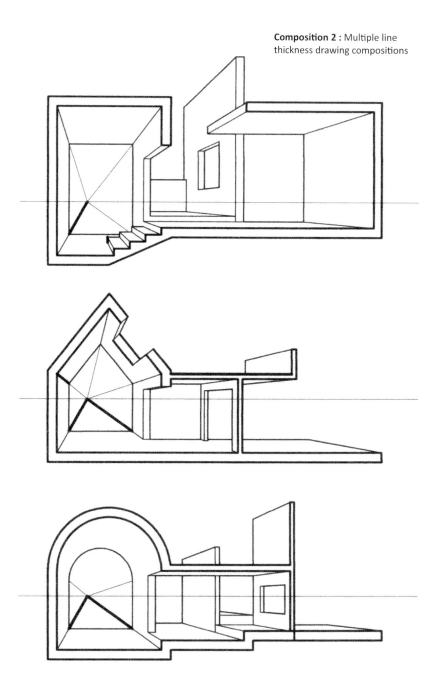

3.0 Sketching

Sketching is an important skill that helps designers throughout the design process, from conceptualising ideas to designing compositions. Sketching is a technique that allows for fast visualisation and can be used to transfer ideas or design compositions onto drawing surfaces. Sketching skills can be learnt and acquired by understanding the knowledge and skills of sketching. Sketching knowledge refers to the knowledge of basic sketching techniques, sketching media, and sketching subjects. Two examples of basic sketching knowledge that must be grasped are handling a pen or a pencil properly and using appropriate lines. Examples of basic sketching skills that must be acquired are the abilities to draw lines and compositions in two and three dimensions. This chapter begins with pen and pencil lines in sketching compositions, and continues with sketching diagrams. The chapter ends with demonstrating examples that show how the skill of sketching is used in the design process.

3.1 Sketching Medium

You can sketch using any suitable medium such as dry, semi-wet, or wet media. The most common media for freehand sketching are pencils and pens. Pencils are categorised as dry media while pens are categorised as semi-wet and wet media.

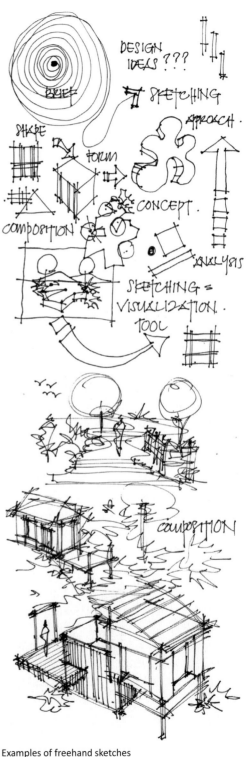

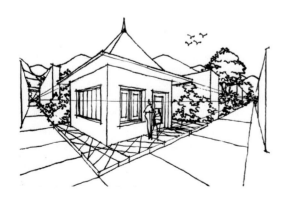

Examples of freehand sketches and compositions

3.1.1 Sketching with Pen

Sketching with a pen is an interesting process. Pen lines are sketched with different line thickness. This is achieved by using felt-tip pens or technical pens. Different line thicknesses produce different visual outputs in the sketch compositions. Observe these examples of sketch compositions, which use different types of lines.

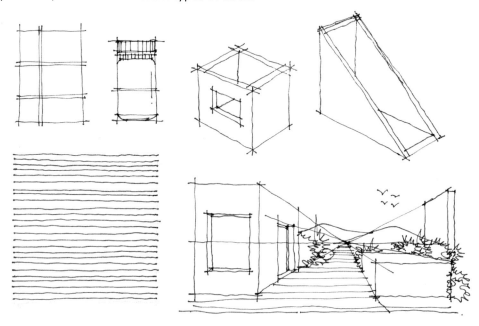

Compositions sketched using a felt-tip pen with 0.2 thickness

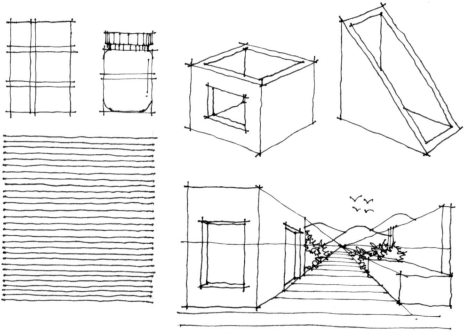

Compositions sketched using a felt-tip pen with 0.4 thickness

Different visual outputs are created using different line thicknesses. Designers need to be able to select the right and appropriate line thickness in their sketch compositions. It is good to explore and understand the different visual outputs of each line thickness before you start sketching a composition.

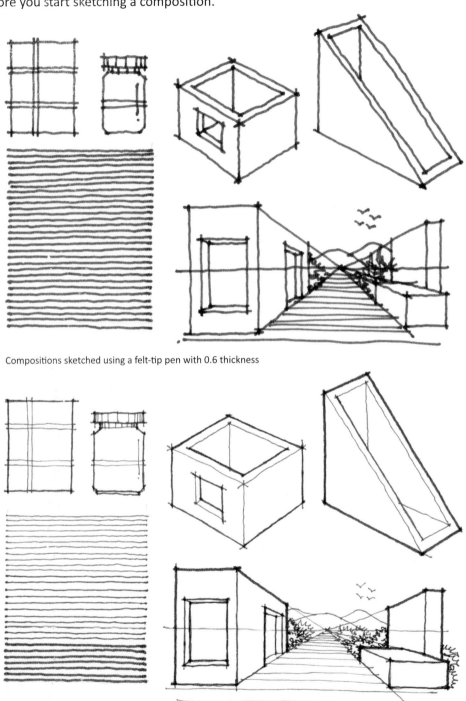

Compositions sketched using a felt-tip pen with 0.6 thickness

Compositions sketched using felt-tip pens with 0.2, 0.4 and 0.6 thickness

3.1.2 Sketching with Pencil

Sketching with a pencil is a unique process. Pencil lines are sketched using pencil grades, which are categorised according to hardness (H) and darkness (D). Different visual outputs may be created using varying pencil grades.

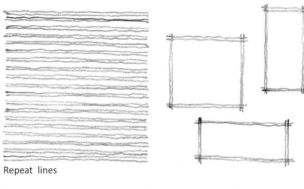

Repeat lines

3.1.3 Sketching Lines

Many types of lines can be created using pencils. You are free to choose any type of pencil line to produce sketches or drawing compositions. Below are some examples of line strokes that can be created using pencils.

i. Freehand lines
ii. Punch lines
iii. Construction lines
iv. Repeat lines
v. Variable lines

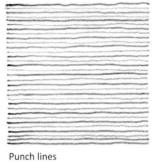
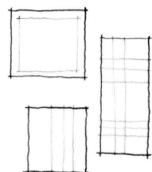

Punch lines

Freehand lines Variable lines Construction lines

Freehand Lines

These are examples of sketches drawn with freehand lines. Freehand lines are simple lines that are used to form sketches.

Examples of pencil sketches created using freehand lines

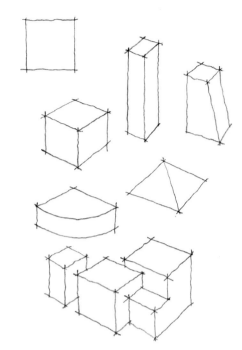

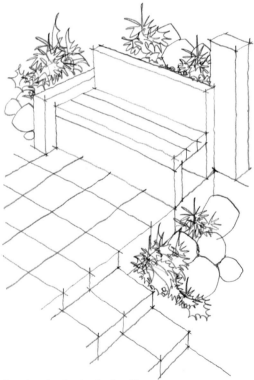

Forms created using freehand lines

A garden sketch using freehand lines

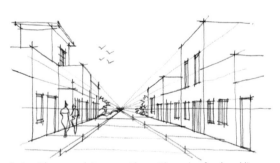

A street in one point perspective setting using freehand lines

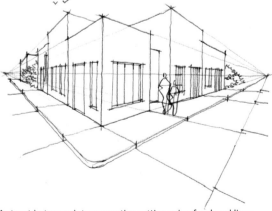

A street in two point perspective setting using freehand lines

Examples of pen sketches using freehand lines

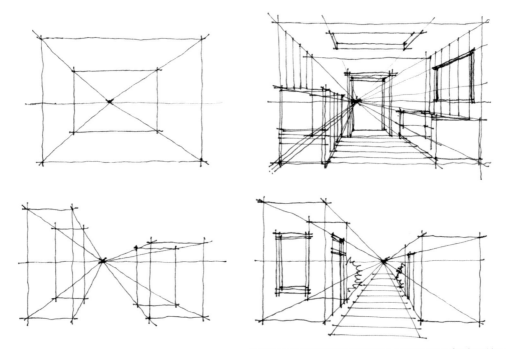

Sketches of one point perspective settings using freehand lines

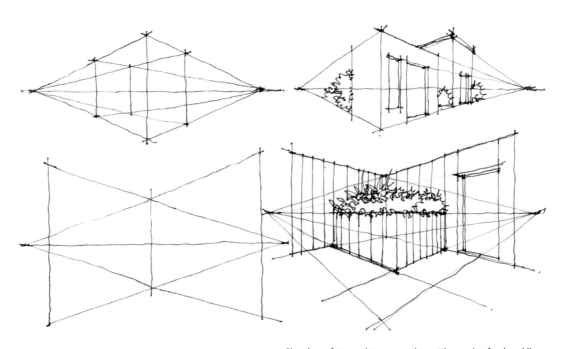

Sketches of two point perspective settings using freehand lines

Outer Lines

Outer lines highlight the profile of an object or a setting in a sketch composition. These are examples of sketch compositions using outer lines.

Examples of pencil sketches using outer lines

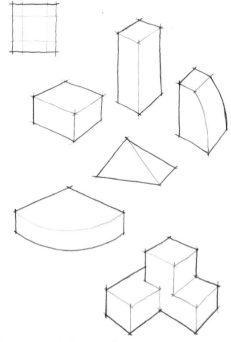

Forms created using outer lines

A garden sketch using outer lines

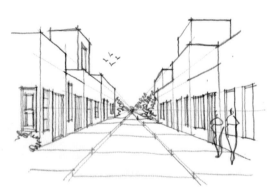

A street in a one-point perspective setting using outer lines

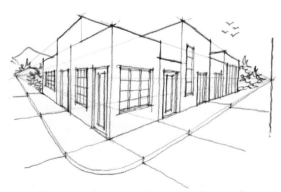

A street in a two-point perspective setting using outer lines

Examples of pen sketches using outer lines

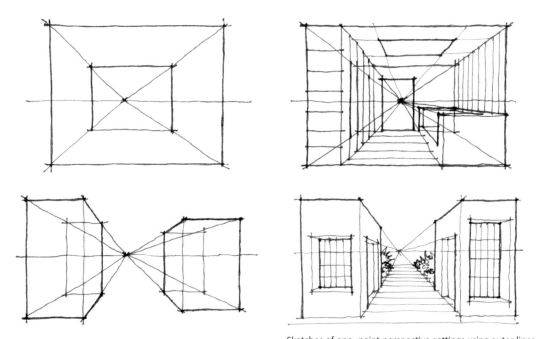

Sketches of one- point perspective settings using outer lines

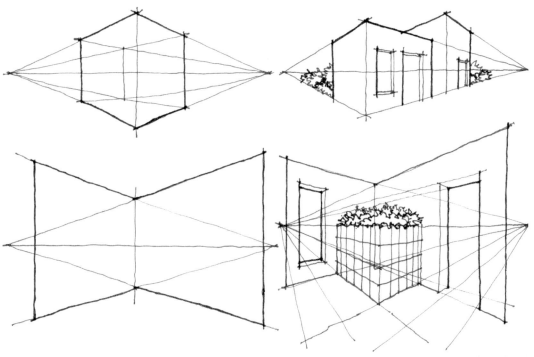

Sketches of two-point perspective settings using outer lines

Construction lines

Construction lines lend an unfinished visual impact to a sketch composition. Here are some examples of sketch compositions using construction lines.

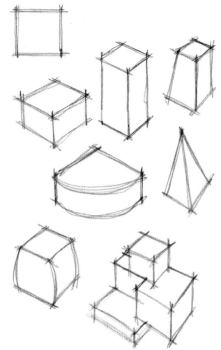

Examples of pencil sketches using construction lines

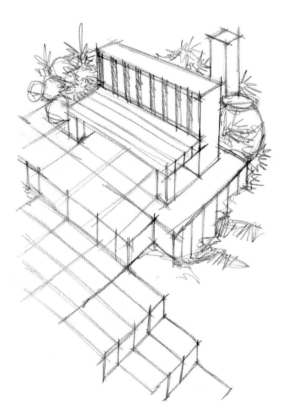

Forms created using construction lines

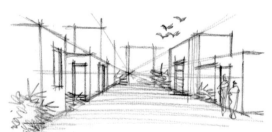

A street in a one-point perspective setting using construction lines

A garden sketch using construction lines

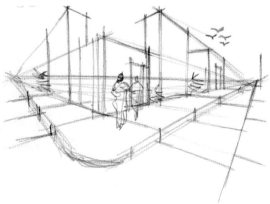

A street in a two-point perspective setting using construction lines

Examples of pen sketches using construction lines

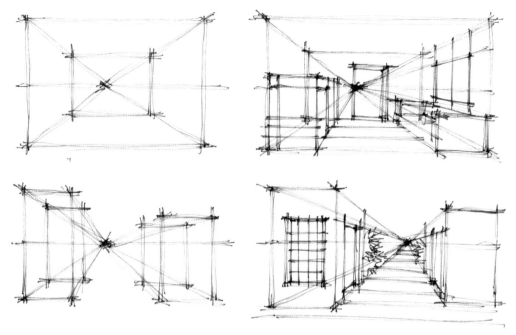

Sketches in one-point perspective settings using construction lines

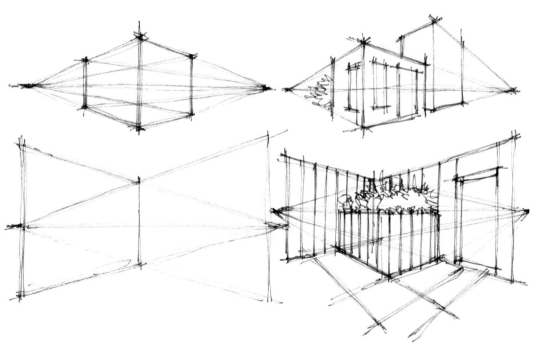

Sketches in two-point perspective settings using construction lines

Double Lines

Double lines create an interesting composition. The second lines strengthen the visual output of the first lines of a sketch composition.

Examples of pencil sketches created using double lines.

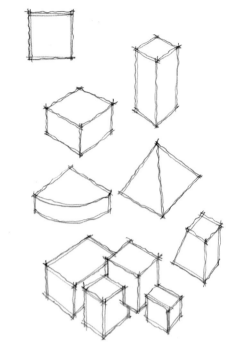

Forms created using double lines

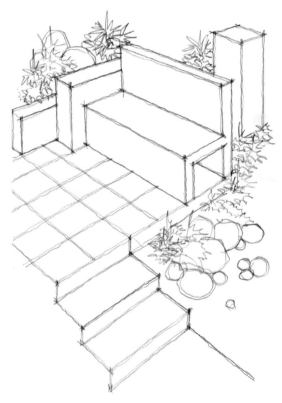

A garden sketch using double lines

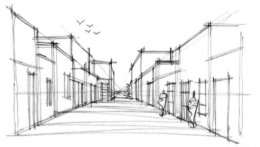

A street in a one point perspective setting using double lines

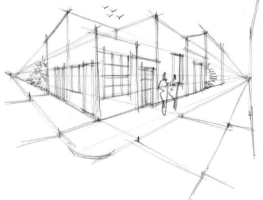

A street in a two point perspective setting using double lines

Examples of pen sketches using double lines

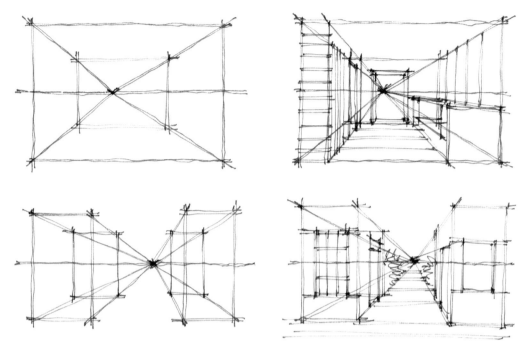

Sketches in one point perspective settings using double lines

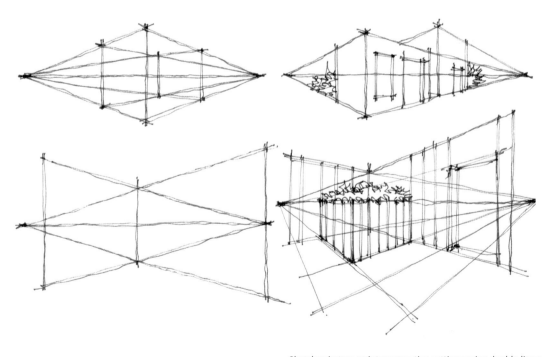

Sketches in two point perspective settings using double lines

Variable lines

Variable lines consist of lines of different weight in a composition. Sketch compositions using variable lines produce interesting and unique visual outputs.

Examples of pencil sketches created using variable lines

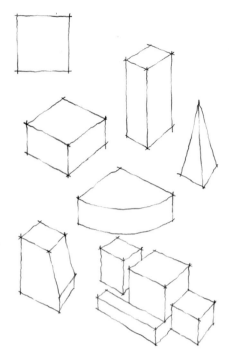

Forms created using variable lines

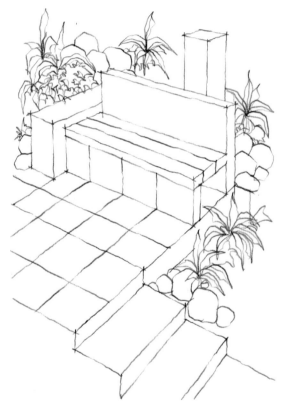

A garden sketch using variable lines

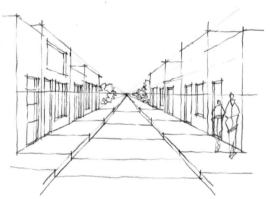

A street in a one point perspective setting using variable lines

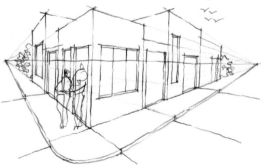

A street in a two point perspective setting using variable lines

Examples of pen sketches using variable lines

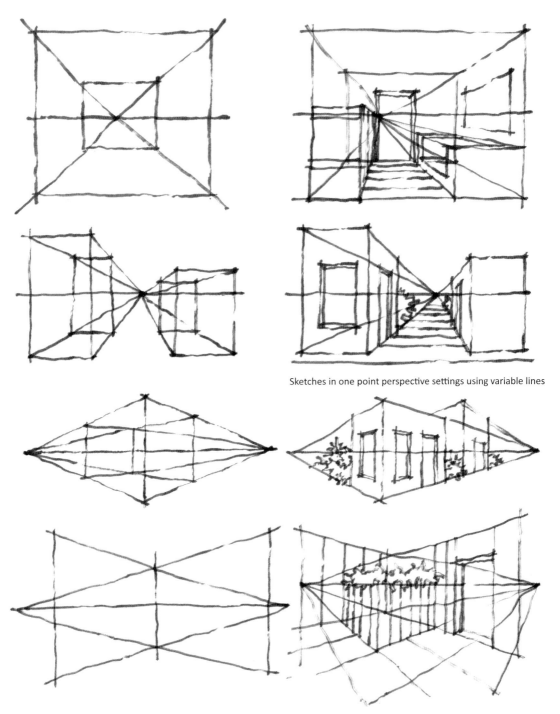

Sketches in one point perspective settings using variable lines

Sketches in two point perspective settings using variable lines

Example 1: Different types of rendering media used for a sketch composition

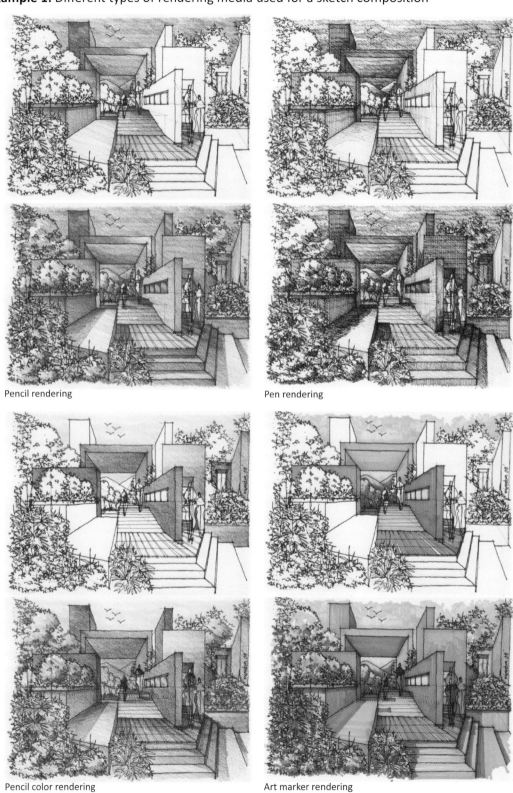

Pencil rendering

Pen rendering

Pencil color rendering

Art marker rendering

Example 2: Different types of rendering media used for a sketch composition

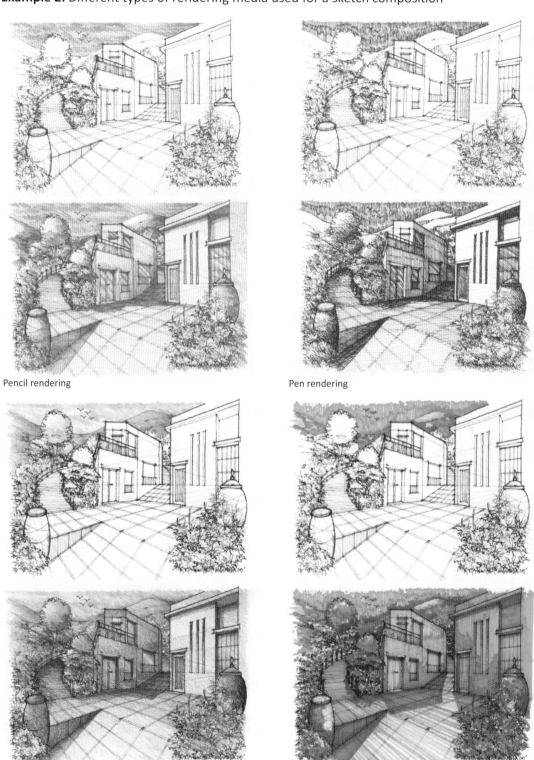

Pencil rendering

Pen rendering

Pencil color rendering

Art marker rendering

Example 3: Different types of rendering media used for a sketch composition

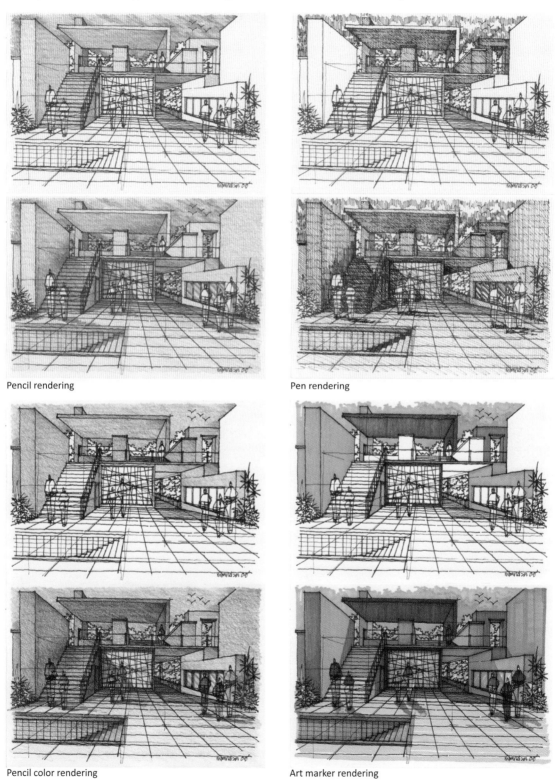

Pencil rendering

Pen rendering

Pencil color rendering

Art marker rendering

Example 4: A digital rendering of sketch compositions

Sketch composition 1

Sketch composition 2

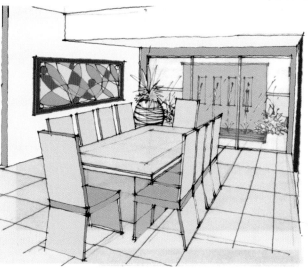

3.2 Sketching Figures

Sketching figures is a must in a design composition. Figures are used as a reference to scale and give proportion to compositions. There are many simple techniques involved in the composition of freehand figures. Here are some examples of simple human figure positions.

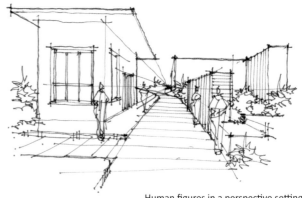

Human figures in a perspective setting

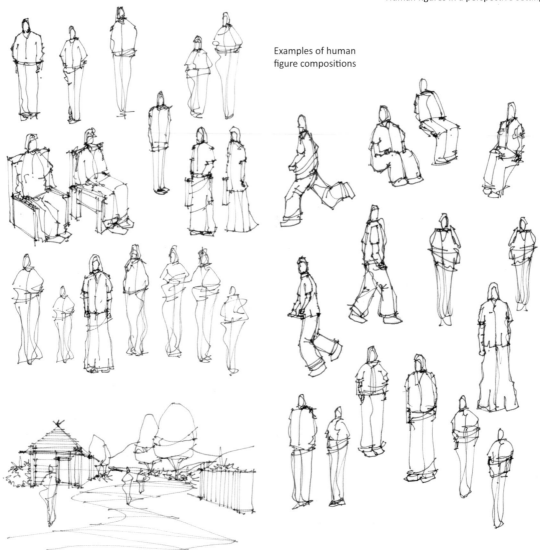

Examples of human figure compositions

Human figures in a perspective setting

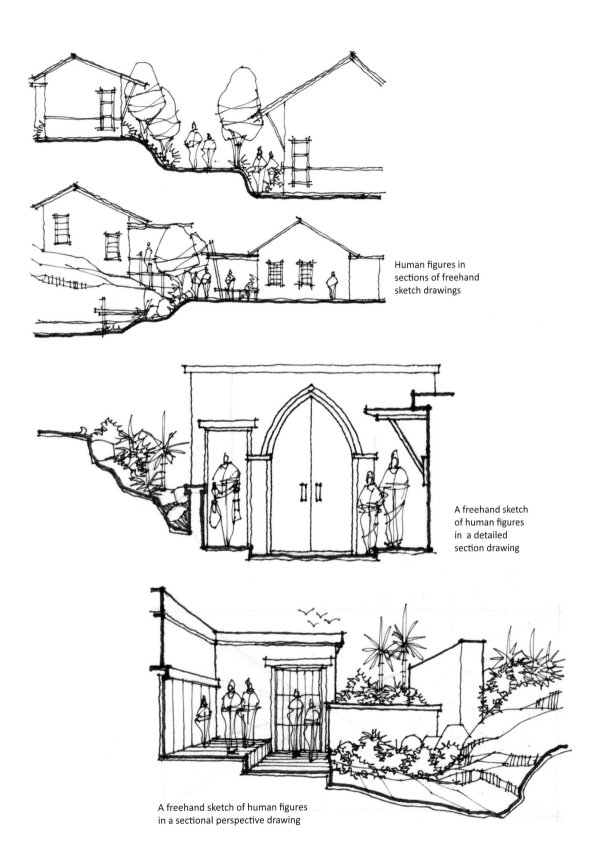

Human figures in
sections of freehand
sketch drawings

A freehand sketch
of human figures
in a detailed
section drawing

A freehand sketch of human figures
in a sectional perspective drawing

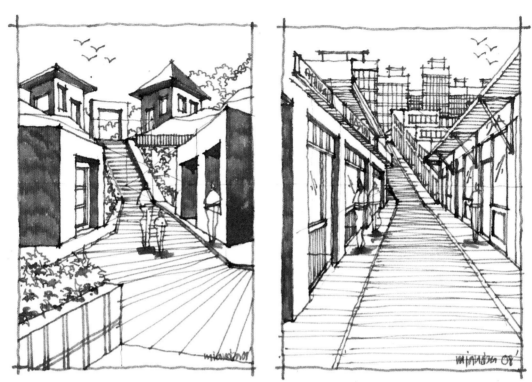

Human figures in sketch compositions with different view angles

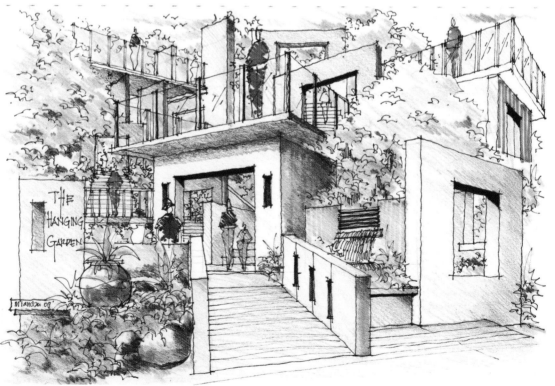

Human figures in a sketch composition with multi level platform

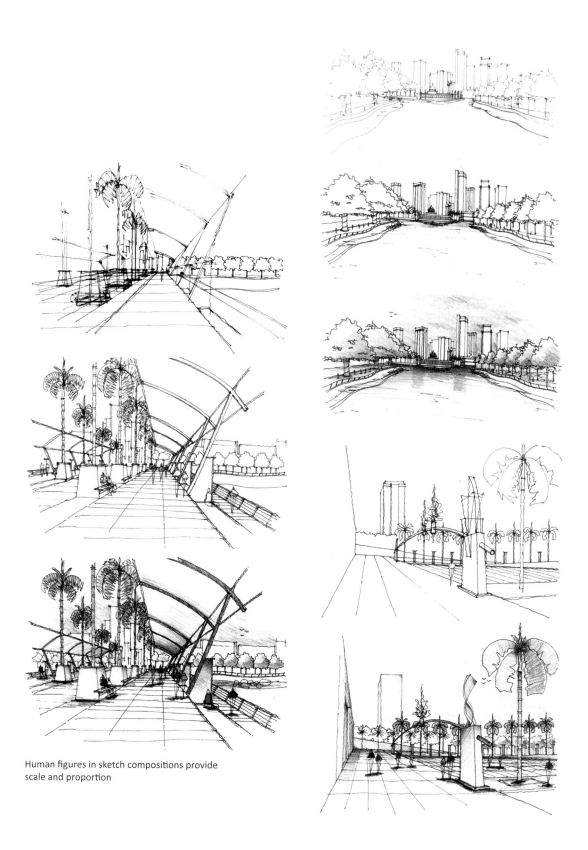

Human figures in sketch compositions provide
scale and proportion

3.3 Sketching Diagrams

It is necessary to sketch diagram in the design process. The main function of a diagram is to simplify the explanation of an idea or design process.

The explanation is done through the use of symbols, signs, abstract figures, basic shapes as well as simple drawing compositions. Diagrams also function as a study medium to analyse and clarify any subjects of design before a design decision can be made. Observe the examples of sketch diagram compositions that are used in the design process.

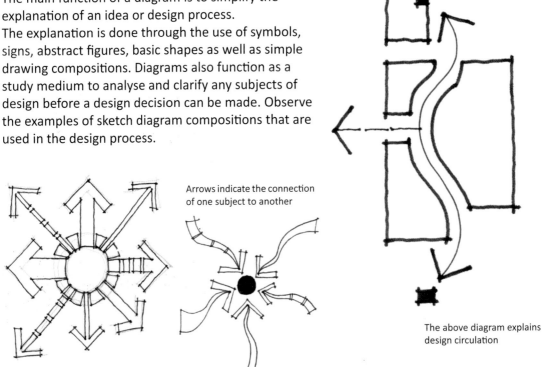

Arrows indicate the connection of one subject to another

The above diagram explains design circulation

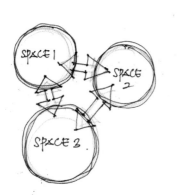

A bubble diagram shows the relationship between spaces or activities

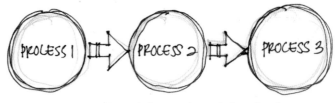

Network diagrams demonstrate or describe processes or procedures in a design idea or development

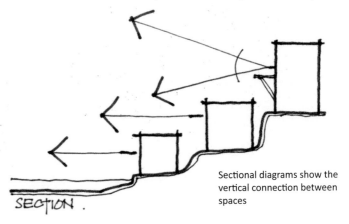

Sectional diagrams show the vertical connection between spaces

3.3.1 Types of diagrams

There are many types of diagrams used to explain design ideas, processes, or developments. The types of diagrams that are frequently used in design processes are network, bubble, analytical, and schematic diagrams. Do explore other diagrams that can assist you in the design process.

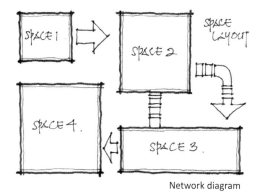

Network diagram

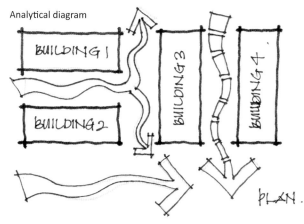

Analytical diagram

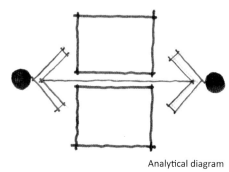

Analytical diagram

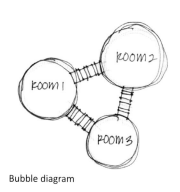

Bubble diagram

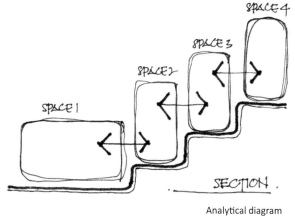

Analytical diagram

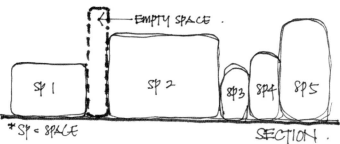

Analytical diagram

3.3.2 Simplifying Visual Communication

Sometimes, it is difficult to understand a subject or an idea without using diagrams. Here are three examples that show how diagrams help to simplify and visually communicate subject matter.

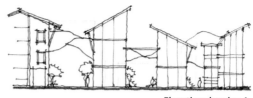

Elevation drawing 1

Plan of a town

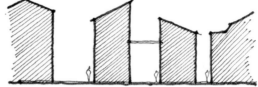

Diagram 1: Spaces between buildings

Diagram 2: Connection between spaces

Diagram 1: Building and open spaces

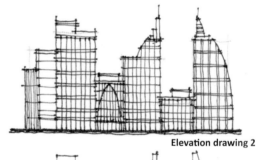

Elevation drawing 2

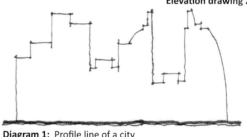

Diagram 1: Profile line of a city

Diagram 2: Connection between spaces

Diagram 2: Connection between spaces

Diagrams can also be used in other related design fields, such as landscape design. Diagrams help to simplify information and the visual communication of landscape designs. This is evident in the two examples given here.

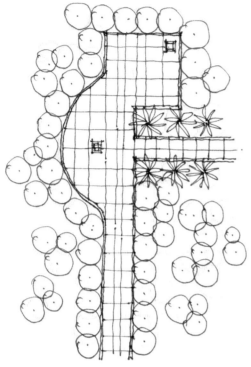

Drawing: Landscape Plan

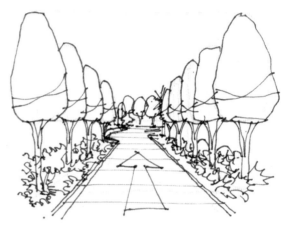

View 1: Landscape space 1

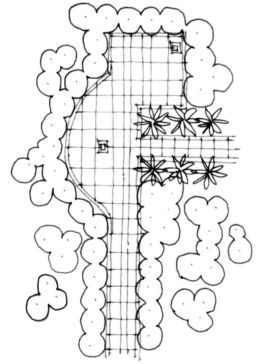

Diagram 1: Landscape layout

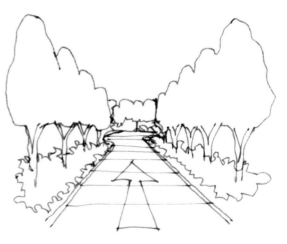

Diagram 2: Landscape space 1

3.3.3 Communicating Ideas

Diagrams are important in communicating an idea or a process. They can help you to visualise certain information that is hard to explain using words. Creativity and sketching skills are needed to create interesting and functional diagrams. Observe the examples given. There are many types of diagrams used to explain the formation of two spaces along the streets.

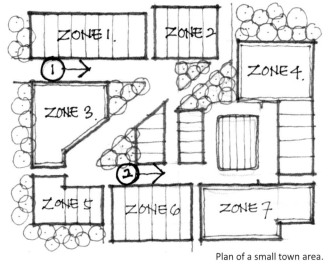

Plan of a small town area.

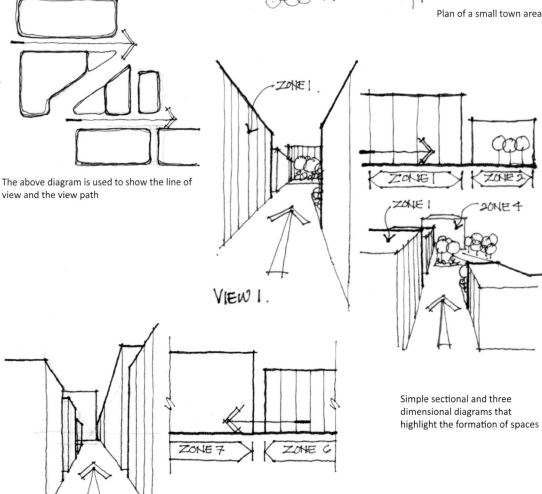

The above diagram is used to show the line of view and the view path

Simple sectional and three dimensional diagrams that highlight the formation of spaces

3.3.4 Three Dimensional Diagrams

When it gets difficult to explain something using two dimensional diagrams, three dimensional diagrams may be employed to give more visual information. Here are two examples of three dimensional diagrams.

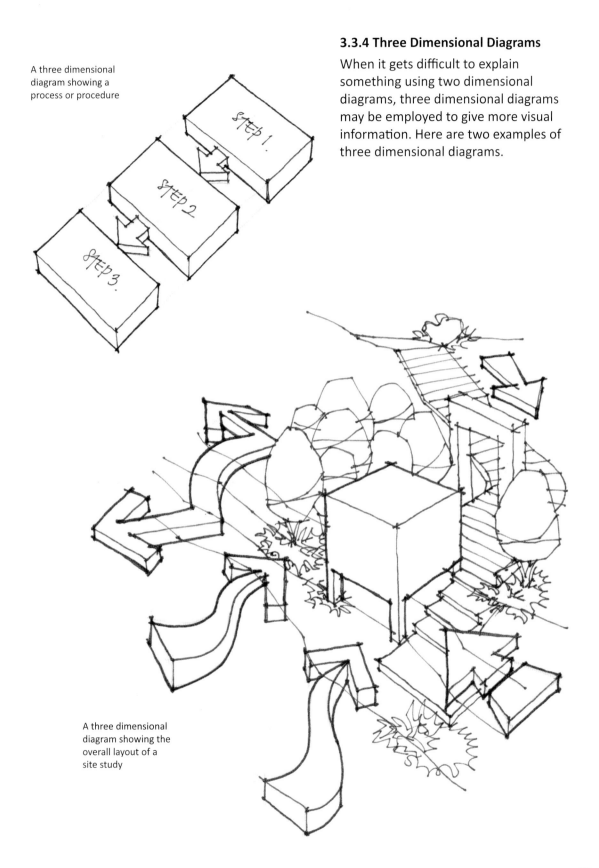

A three dimensional diagram showing a process or procedure

A three dimensional diagram showing the overall layout of a site study

3.3.5 Coloured Diagrams

Diagrams with colours look visually interesting. Colours can enhance the look of a diagram that communicates visual information to an audience. Observe the examples of diagrams given, where colours are employed to emphasise certain information, such as types of spaces and wind directions.

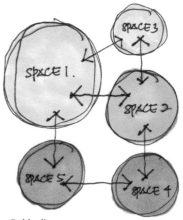

Buble diagram

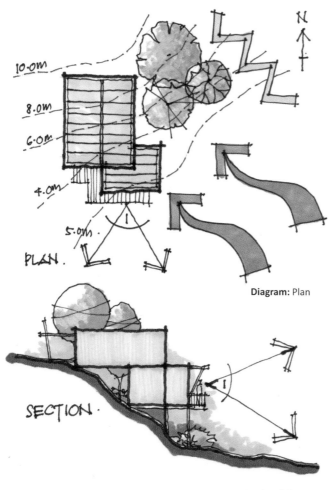

Diagram: Plan

Sectional diagram

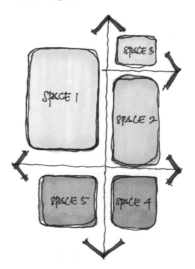

Circulation diagram

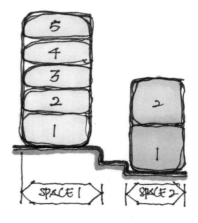

Sectional diagram

Colours also provide clear visual communication when you are differentiating between processes or procedures, particularly in network diagrams. Observe the three examples given where colours are used to make a network diagram more interesting.

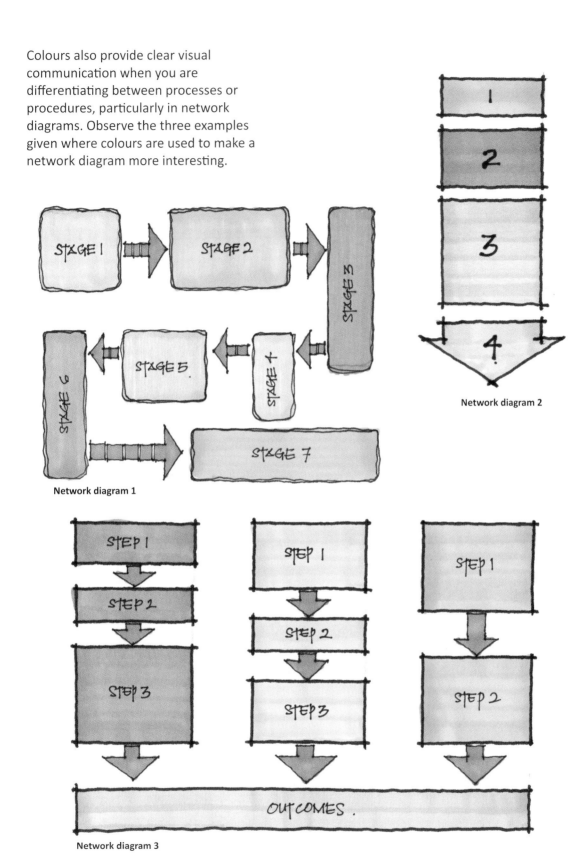

Network diagram 2

Network diagram 1

Network diagram 3

3.4 Sketching A Process

Usually, a design process begins with the sketching of ideas related to a design programme or a site. Different types of diagrams are involved in the design process, such as network, bubble, and analytical diagrams. Designers must be able to choose suitable diagrams to be used in sketching different design processes. Observe the examples here that demonstrate the use of diagrams in a design process.

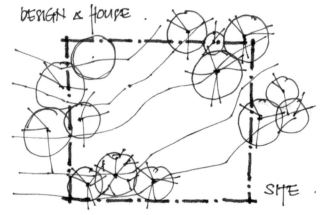

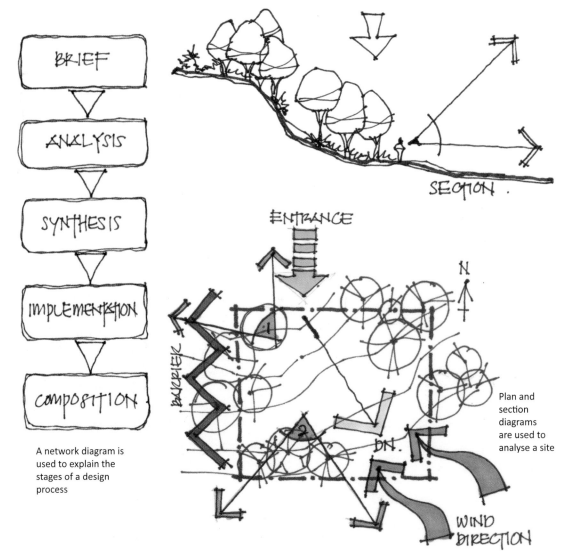

A network diagram is used to explain the stages of a design process

Plan and section diagrams are used to analyse a site

3.4.1 Initiating Ideas

The design process continues by adding bubble diagrams to the sketch of the site. It is important to obtain a good space layout. Schematic forms are sketched according to the positions of the bubbles, which represent the spaces. It is good to sketch your design options before you begin your actual drawings.

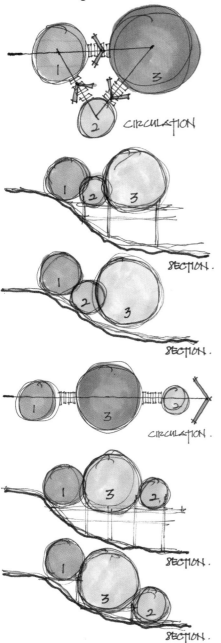

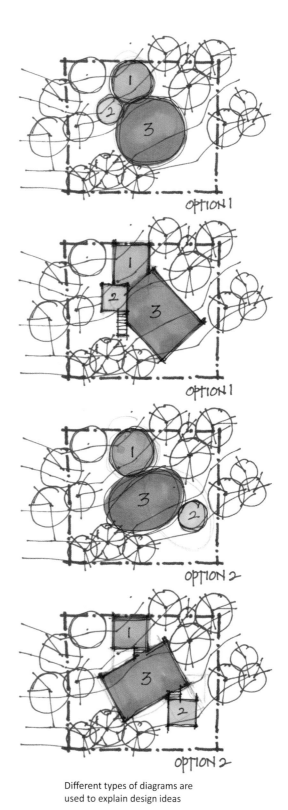

Different types of diagrams are used to explain design ideas

3.4.2 Analysing Ideas

The simple sketch of forms creates interesting analytical diagrams. These diagrams allow designers to explore three dimensional compositions. Sectional diagrams allow designers to understand and explore the cross sections of a site in relation to the proposed design ideas or layout.

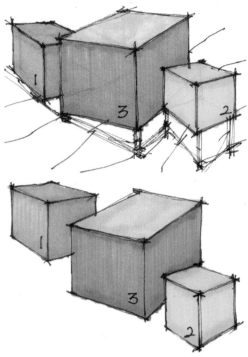

Three dimensional diagrams using simple forms provide a rough layout of design compositions

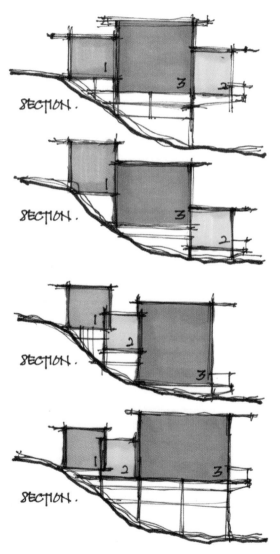

Cross section diagrams show the contours of a site and their relation to a design layout

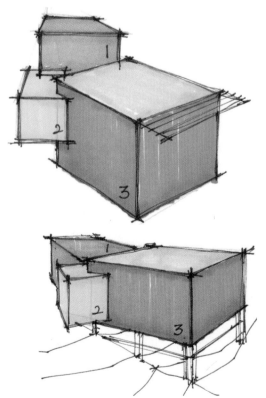

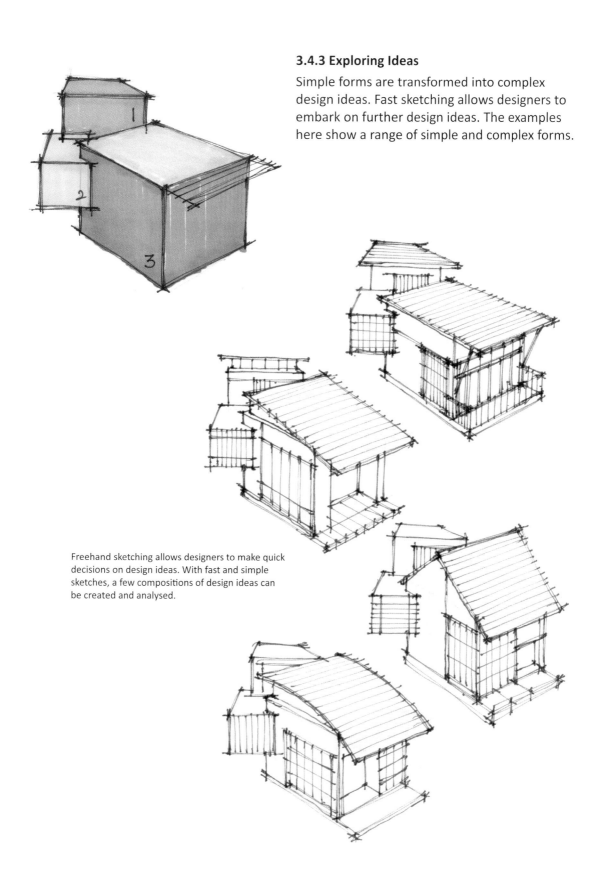

3.4.3 Exploring Ideas

Simple forms are transformed into complex design ideas. Fast sketching allows designers to embark on further design ideas. The examples here show a range of simple and complex forms.

Freehand sketching allows designers to make quick decisions on design ideas. With fast and simple sketches, a few compositions of design ideas can be created and analysed.

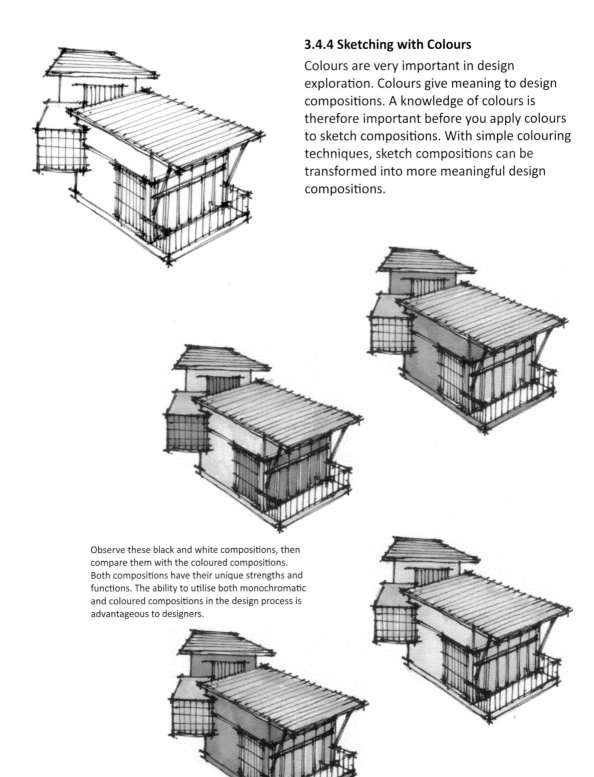

3.4.4 Sketching with Colours

Colours are very important in design exploration. Colours give meaning to design compositions. A knowledge of colours is therefore important before you apply colours to sketch compositions. With simple colouring techniques, sketch compositions can be transformed into more meaningful design compositions.

Observe these black and white compositions, then compare them with the coloured compositions. Both compositions have their unique strengths and functions. The ability to utilise both monochromatic and coloured compositions in the design process is advantageous to designers.

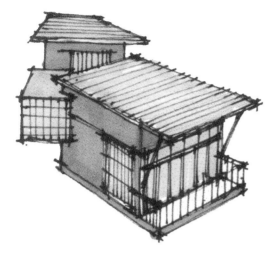

3.4.5 Finalising Ideas with Sketching

It is wise to finalise your ideas using sketches before your actual drawings are completed. Sketching your ideas provides an initial picture of your overall design layout and changes can be made instantly if necessary.

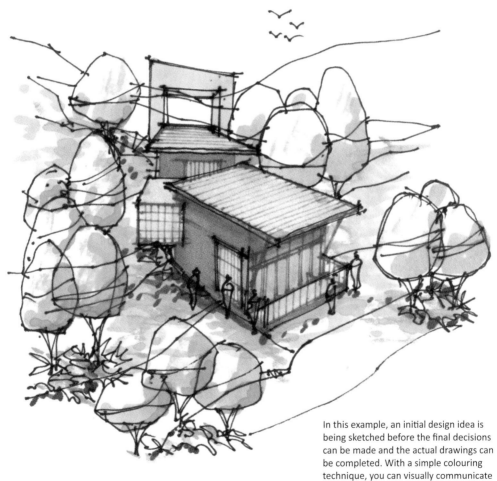

In this example, an initial design idea is being sketched before the final decisions can be made and the actual drawings can be completed. With a simple colouring technique, you can visually communicate design information to an audience through this sketch.

4.0 Design Drawings

Design drawings belong to part of a bigger category of drawings. Design drawings are used to visually design ideas or compositions. These drawings should be able to efficiently and visually communicate to an audience the intention of design ideas or compositions. Design drawing is a broad subject that involves many disciplines in the design profession. Design drawings are used in many different fields, such as architecture, landscape architecture, interior architecture, and industrial design. However, the basic principles of design drawings in these fields remain the same. These fields employ the same drawing systems, such as plans, sections, elevations, and perspectives.

Building drawing 1: Section (Mechanical drawing)

Building drawing 2: Detailing (Mechanical drawing)

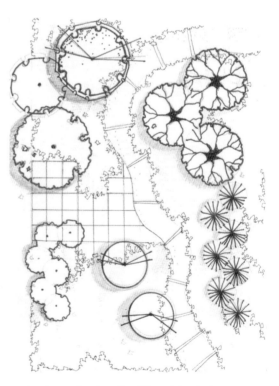

Landscape drawing : Plan (Manual drawing)

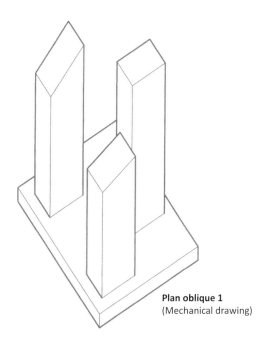

Plan oblique 1
(Mechanical drawing)

The ability to produce good design drawing compositions allows for more interesting and comprehensible visual communication.

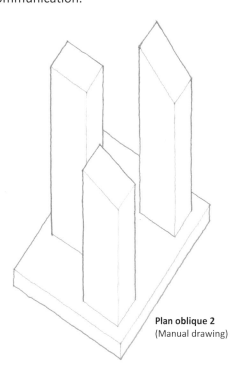

Plan oblique 2
(Manual drawing)

Design drawings can be produced either manually or mechanically. Manual drawings are produced using pens or pencils while mechanical drawings are produced using software and printed through printers or plotters. Here are three examples of manual and mechanical drawings, each with their own characteristics.

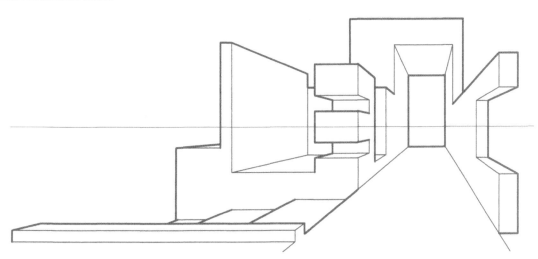

One-Point Perspective Drawing (Mechanical drawing)

4.1 Drawing Types

There are many types of design drawings, such as plans, sections, elevations, and perspectives. These drawings are categorised as follows:

i Orthographic Projection
ii. Oblique Projection
iii. Axonometric Projection
iv. Perspective Projection

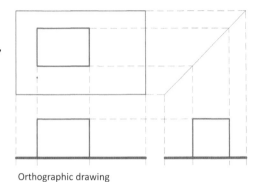

Orthographic drawing

Plan oblique drawing 1

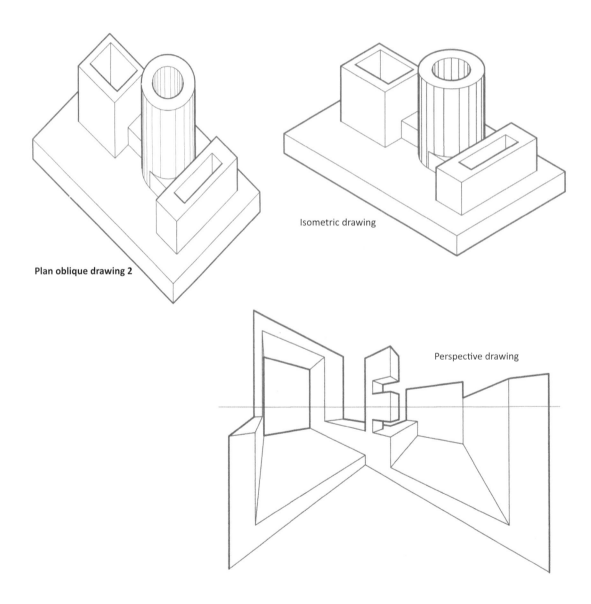

Plan oblique drawing 2

Isometric drawing

Perspective drawing

4.1.1 Orthographic Projection

Orthographic projection is a projection drawing system that is used to produce drawings such as plans, sections, and elevations for an object composition.

Basic Composition

Observe the three examples given, which demonstrate the process of creating basic objects using an orthographic projection system. Different types of lines and line thicknesses are used in this process in order to highlight the object compositions.

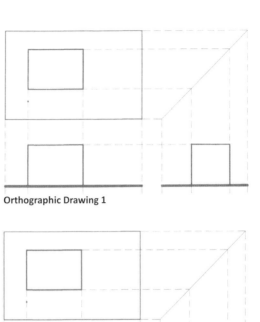

Orthographic Drawing 1

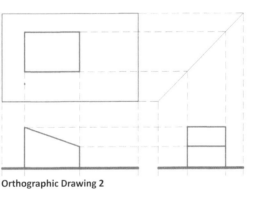

Orthographic Drawing 2

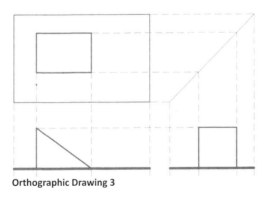

Orthographic Drawing 3

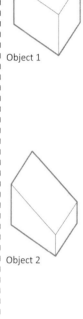

Object 1

Object 2

Object 3

Complex Composition 1

Complex Composition 1 comprises of a few basic objects located on a level platform. Observe the process of creating this complex composition using the orthographic projection system. This process constitutes projecting lines from the plan to form sections and elevations. It is advisable to complete the plan and section drawings before continuing with elevation drawings.

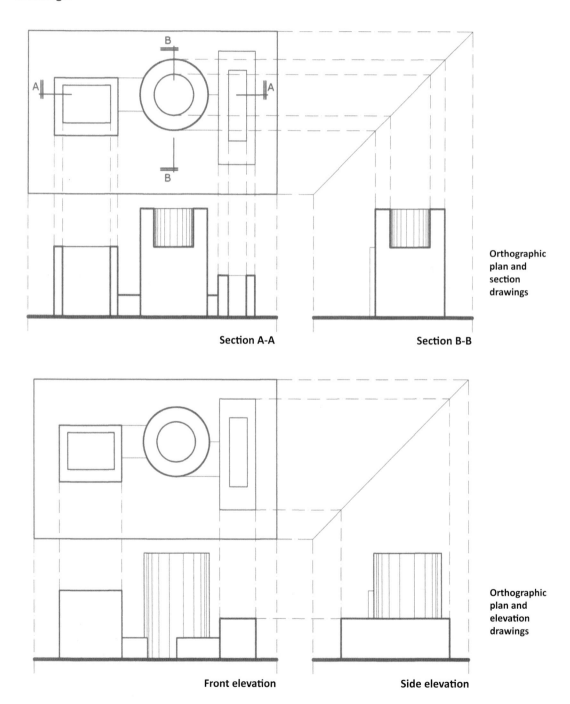

Section A-A

Section B-B

Orthographic plan and section drawings

Front elevation

Side elevation

Orthographic plan and elevation drawings

Complex Composition 2

Complex Composition 2 comprises of a few basic objects located on a split-level platform. A similar process as that in Complex Composition 1 is involved, where lines are projected on two different platforms: level and split-level platforms. It is important to understand the orthographic principles that make the process of projecting the sections and elevations easier.

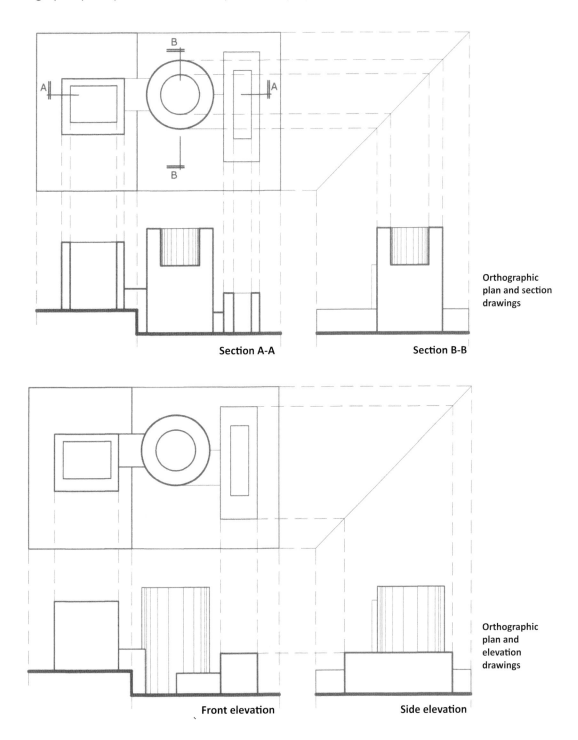

Section A-A Section B-B

Orthographic plan and section drawings

Front elevation Side elevation

Orthographic plan and elevation drawings

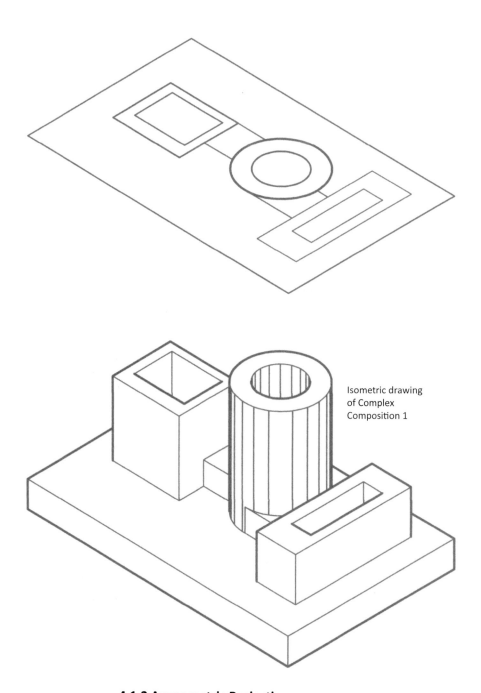

Isometric drawing
of Complex
Composition 1

4.1.2 Axonometric Projection

Axonometric projection involves perpendicularly projecting a three dimensional drawing on to a picture plane. Isometric projection is part of axonometric projection. Observe the isometric drawing given. It is not constructed by using the isometric projection approach but a more common technique used by designers. The isometric drawing uses an object angle of 120°.

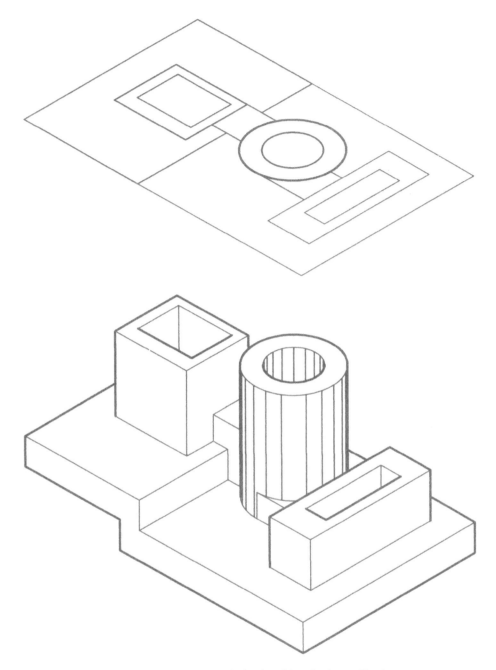

Isometric drawing of Complex Composition 1

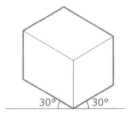

30° 30°

4.1.3 Oblique Projection

Oblique projection involves projecting a three dimensional drawing at an angle that is parallel to a picture plane. One of the components involved in oblique projection is plan oblique. This example demonstrates the simple process of constructing a plan oblique by positioning the plan at 45°. Plans can take on other positions at different angles, such as 30°, 45°, or 60°. After positioning the plan, all the object lines are to form a projected three dimensional composition. The height of the plan oblique composition will be based on the section and elevation drawings.

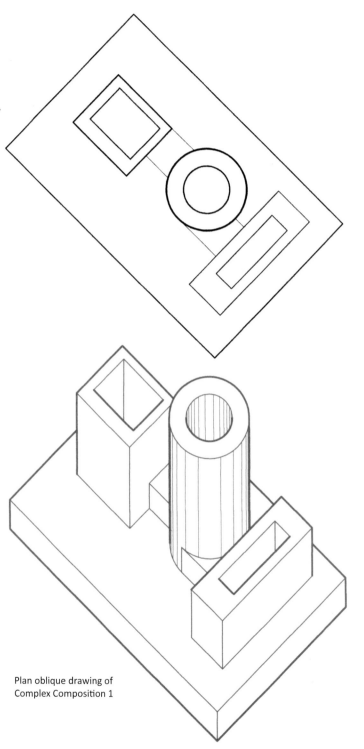

Plan oblique drawing of Complex Composition 1

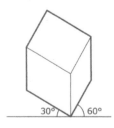

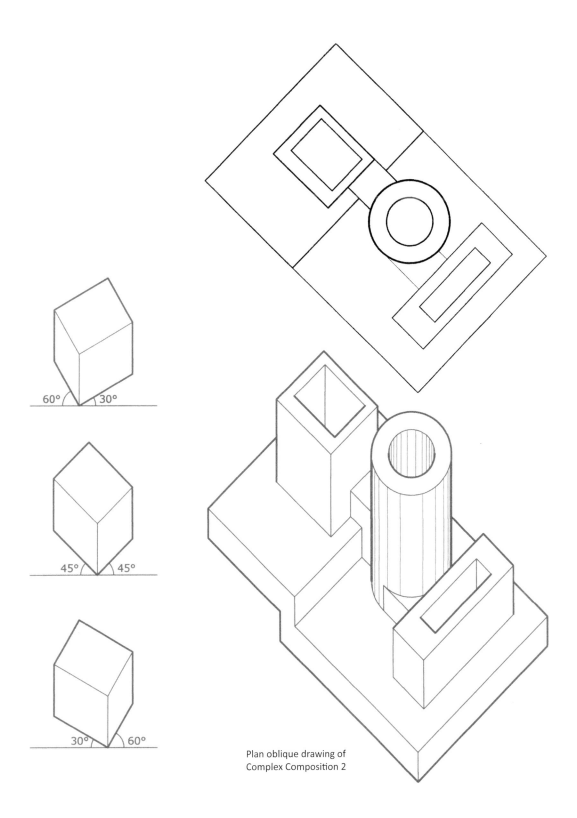

60° 30°

45° 45°

30° 60°

Plan oblique drawing of
Complex Composition 2

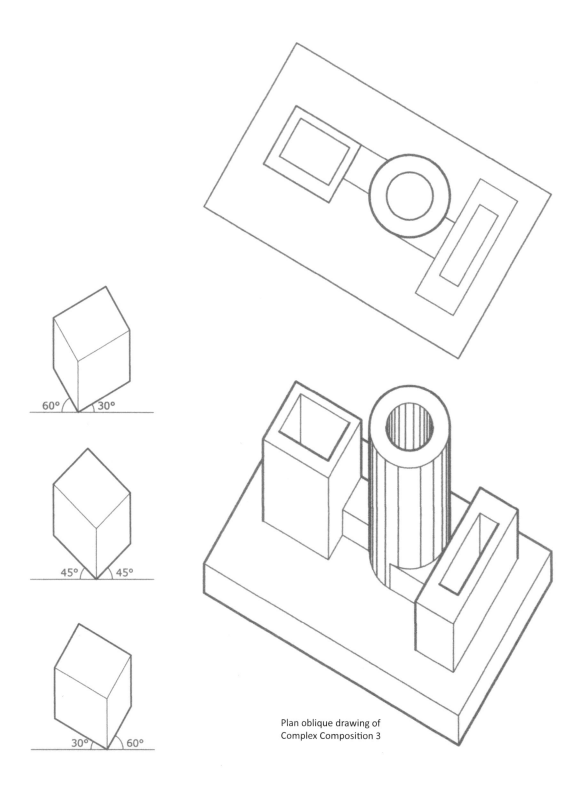

60° 30°

45° 45°

30° 60°

Plan oblique drawing of
Complex Composition 3

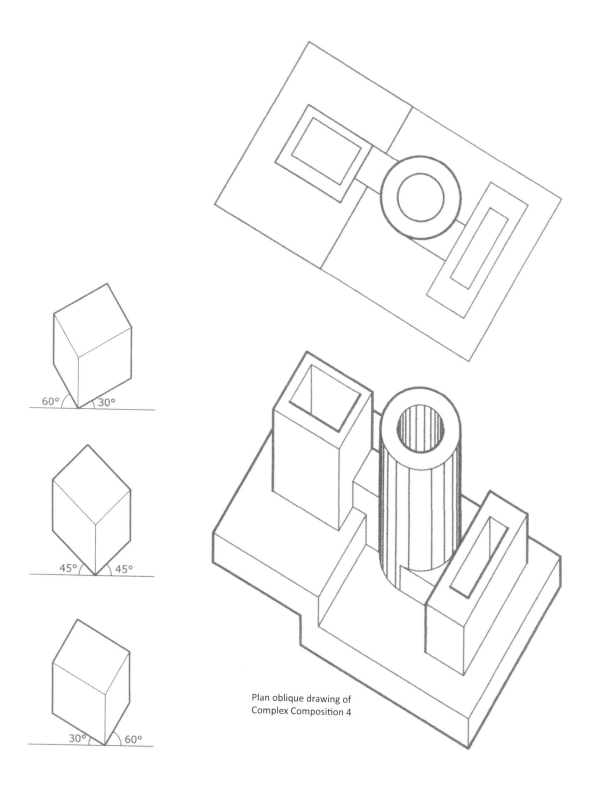

60° 30°

45° 45°

30° 60°

Plan oblique drawing of
Complex Composition 4

4.1.4 Perspective Projection

Perspective drawing is one of the three dimensional drawings that is used to visualise design ideas and compositions. There are a few types of perspective drawings commonly used by designers. These are:

i. One-point perspective
ii. Two-point perspective
iii. Multi-point perspective

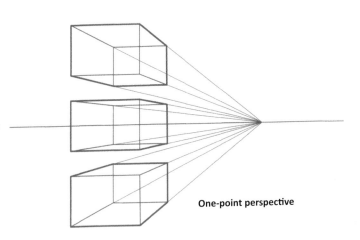

One-point perspective

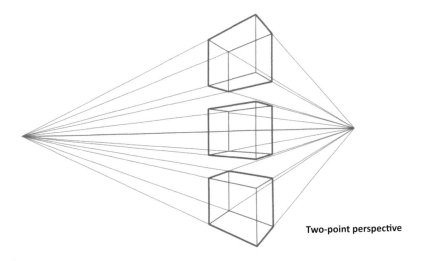

Two-point perspective

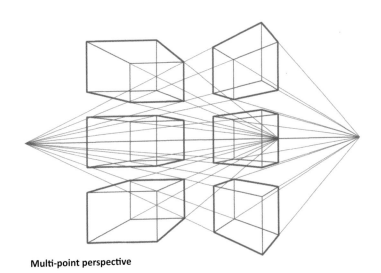

Multi-point perspective

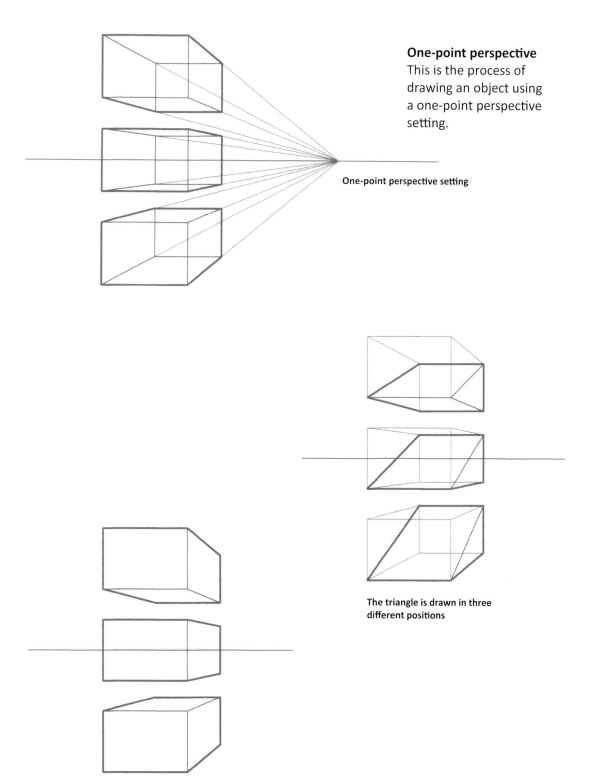

One-point perspective
This is the process of drawing an object using a one-point perspective setting.

One-point perspective setting

The triangle is drawn in three different positions

The box is drawn in three different positions

In this example, an object is being transformed from a basic to a more complex composition. The process continues by adding context to the object composition.

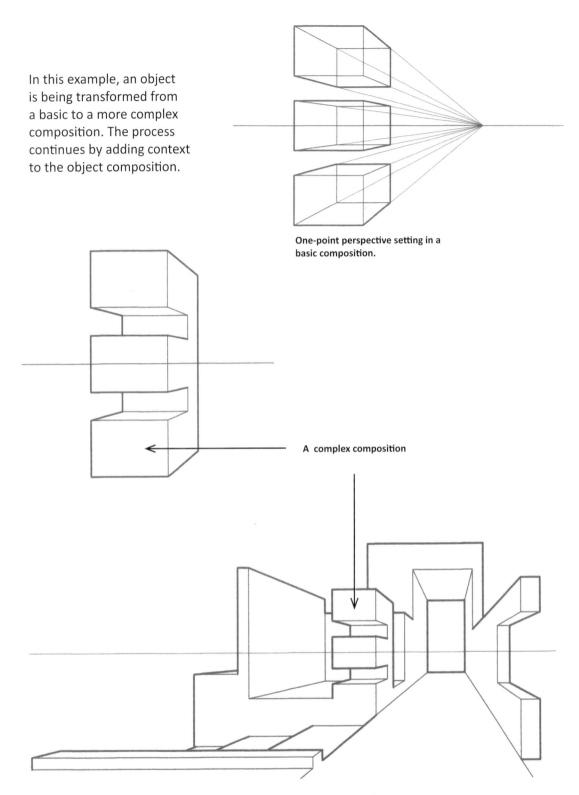

One-point perspective setting in a basic composition.

A complex composition

A complex composition with a context

Two-point perspective
This is the process of drawing an object using a two-point perspective setting.

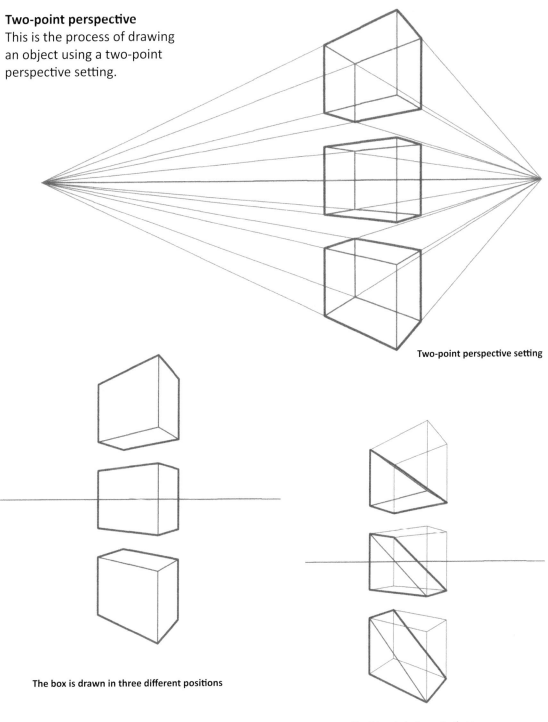

Two-point perspective setting

The box is drawn in three different positions

The triangle is drawn in three different positions

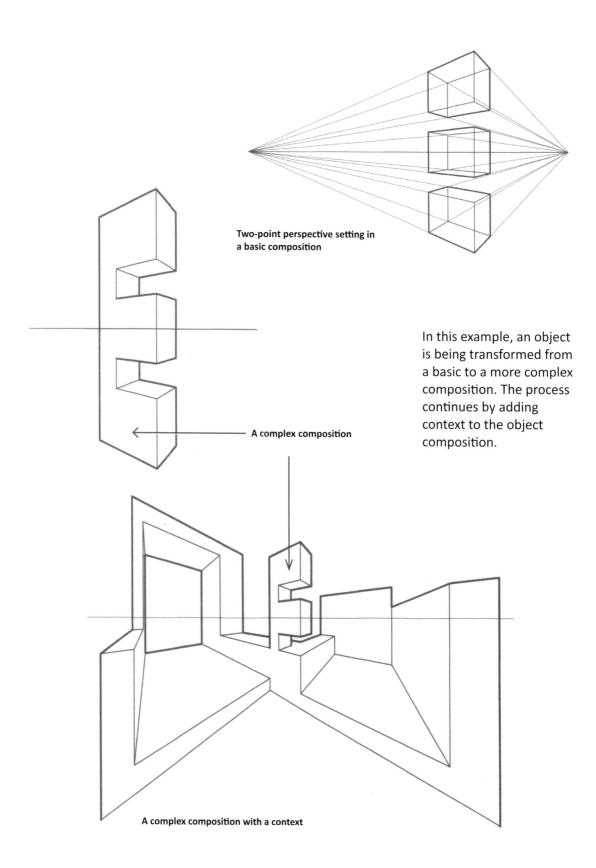

Two-point perspective setting in a basic composition

A complex composition

In this example, an object is being transformed from a basic to a more complex composition. The process continues by adding context to the object composition.

A complex composition with a context

Multi-point perspective

This is the process of drawing an object using a multi-point perspective setting.

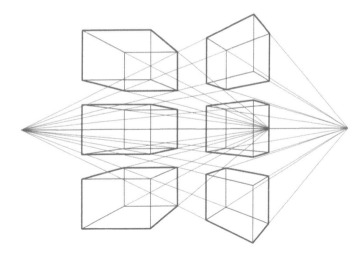

Multi-point perspective setting

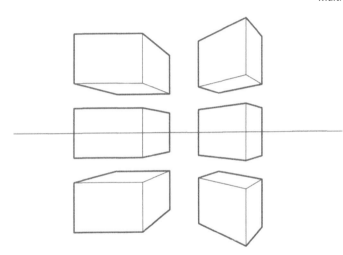

The box is drawn in three different positions

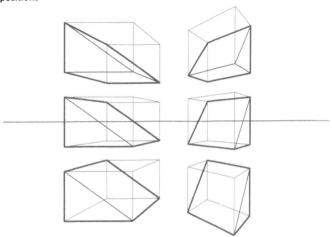

The triangle is drawn in three different positions

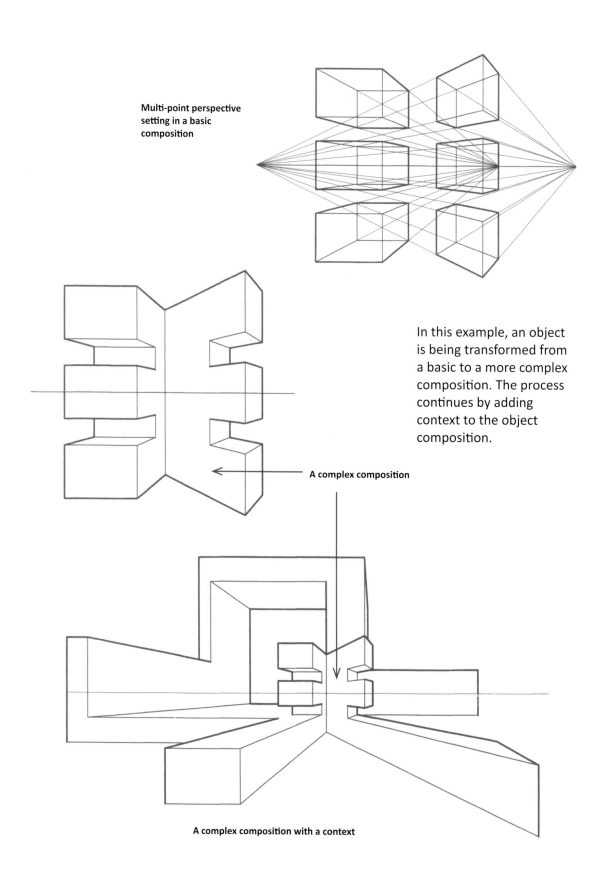

Multi-point perspective setting in a basic composition

In this example, an object is being transformed from a basic to a more complex composition. The process continues by adding context to the object composition.

A complex composition

A complex composition with a context

4.2 Drawing Compositions

You need good drawing compositions to demonstrate good visual communication of your design ideas or compositions to your audience. Knowledge and drawing skills are necessary to produce a good drawing composition.There are several kinds of essential knowledge: knowledge of drawing types, line types, and types of media you can use, as well as knowledge of design composition, which involves design characters, structures, materials, and scale. Meanwhile, you must acquire good drawing skills by practising techniques of manual or mechanical drafting.

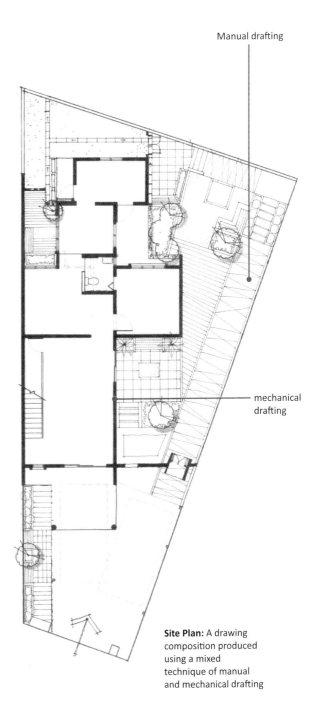

Manual drafting

mechanical drafting

Site Plan: A drawing composition produced using a mixed technique of manual and mechanical drafting

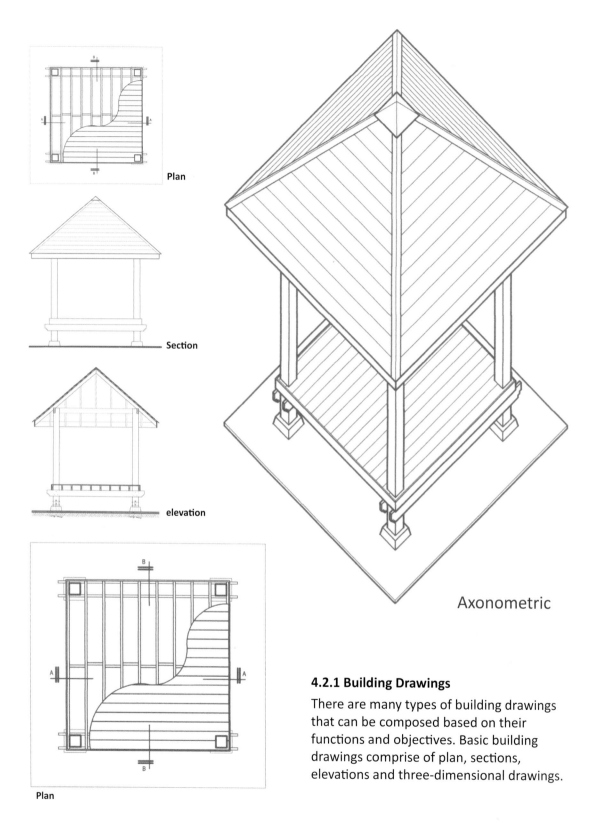

Plan

Section

elevation

Plan

Axonometric

4.2.1 Building Drawings

There are many types of building drawings that can be composed based on their functions and objectives. Basic building drawings comprise of plan, sections, elevations and three-dimensional drawings.

Section A-A

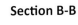

Section B-B

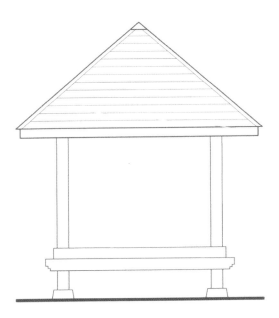

Front Elevation

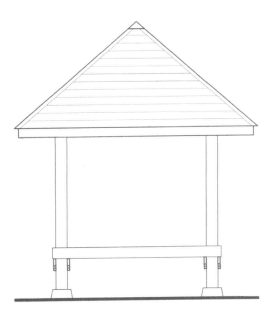

Side Elevation

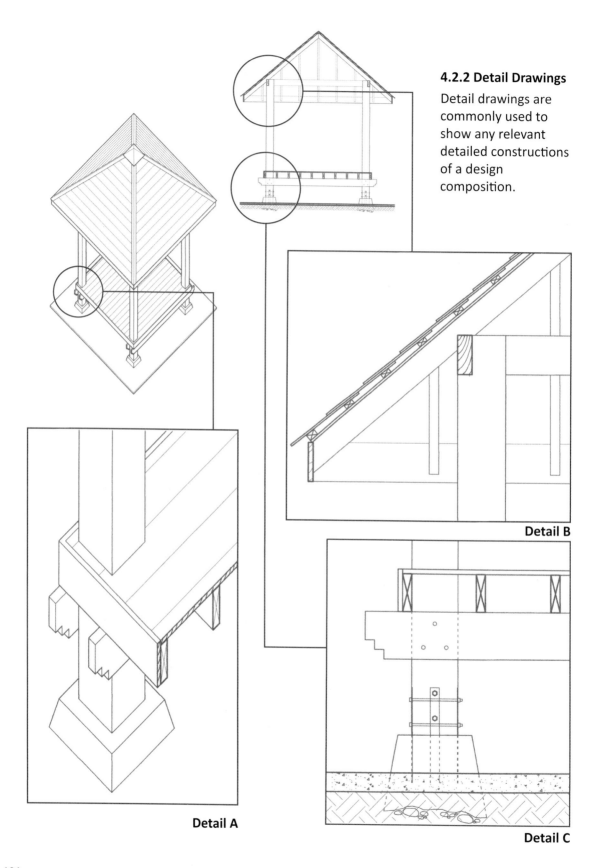

4.2.2 Detail Drawings

Detail drawings are commonly used to show any relevant detailed constructions of a design composition.

Detail B

Detail A

Detail C

4.2.3 Drawings and Lines

A good drawing composition is always dependent on the quality of your line thickness. It is therefore necessary to understand line thickness and the suitability of various line thicknesses. Different drawing scales require different line thicknesses. Observe these examples that show how line thickness influences the production of similar drawing compositions of different scales.

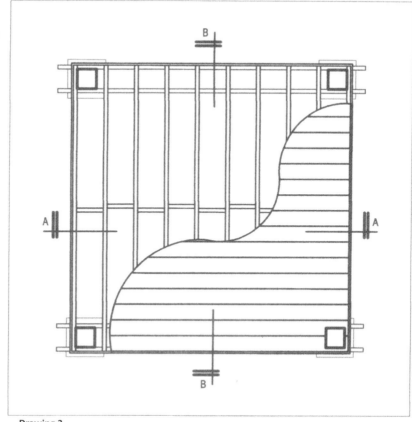

Drawing 1

Drawing 2

Different line thicknesses are needed when dealing with different scales of drawing although it is the same design drawing composition.

Drawing 3

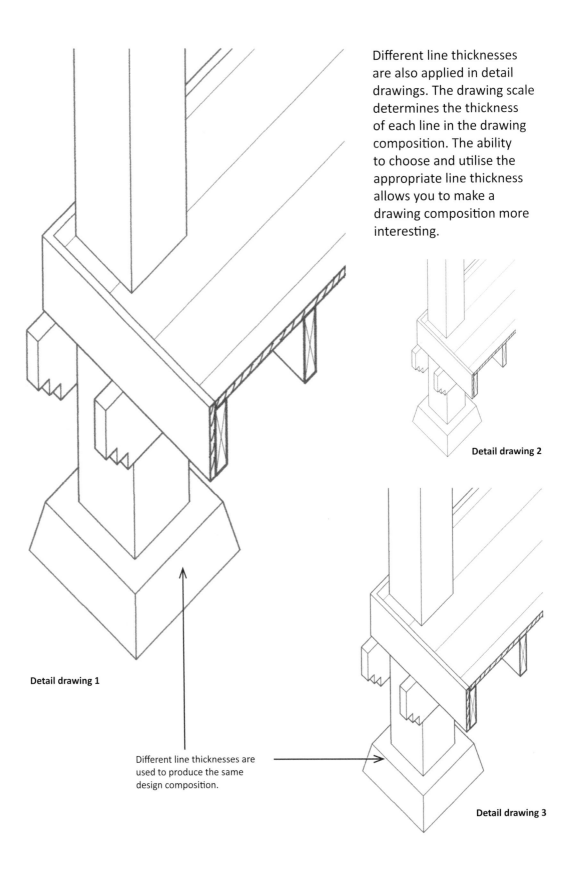

Different line thicknesses are also applied in detail drawings. The drawing scale determines the thickness of each line in the drawing composition. The ability to choose and utilise the appropriate line thickness allows you to make a drawing composition more interesting.

Detail drawing 2

Detail drawing 1

Different line thicknesses are used to produce the same design composition.

Detail drawing 3

Line thickness is also employed in other drawings, such as sectional perspective sketches. When an appropriate line thickness is used in a drawing composition, the composition becomes interesting. The bigger the scale, the thicker the lines should be.

Sectional perspective 1

Different line thicknesses are used to compose the same sectional drawing composition.

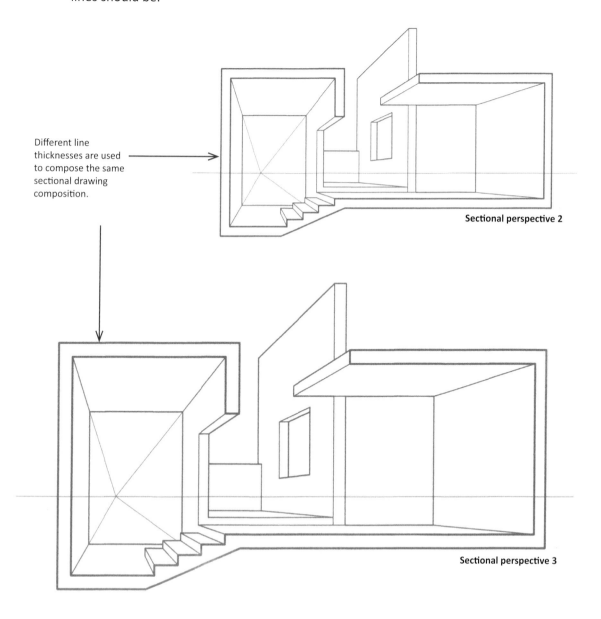

Sectional perspective 2

Sectional perspective 3

It is important to understand the different visual impacts of a perspective drawing composition using a single line thickness and one using multi-line thickness. Drawing compositions that use multi-line thickness are more interesting compared to compositions that use a single line thickness. The ability to choose an appropriate line thickness for your drawing composition will help to create an interesting and good perspective drawing composition.

Multiple line thickness in basic perspective setting 1

Multiple line thickness in basic perspective setting 2

Single in thickness in basic perspective settings

Multiple line thickness in basic perspective setting 3

4.2.4 Landscape Drawings

Landscape drawings are constructed using the same principles as building drawings. Most landscape drawings involve plants, which are normally divided into three categories: ground covers, shrubs, and trees. It is important to learn and understand the characters of each plant before you start to compose landscape drawings.

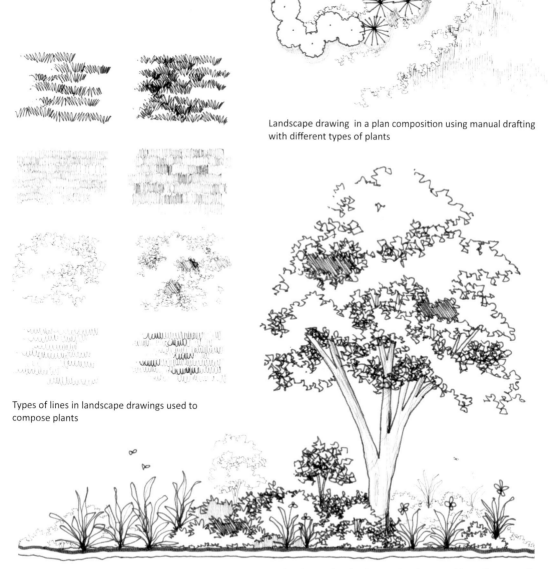

Landscape drawing in a plan composition using manual drafting with different types of plants

Types of lines in landscape drawings used to compose plants

Landscape drawing in a sectional composition using manual drafting with different types of plants

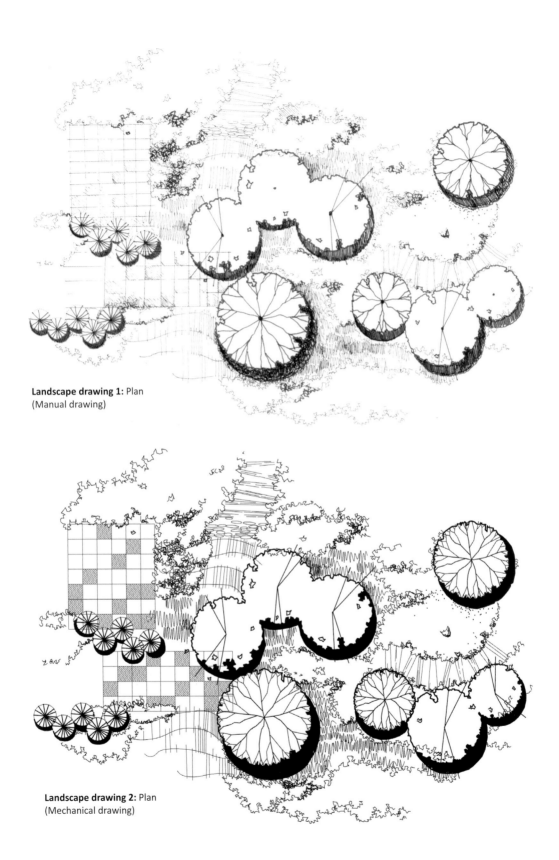

Landscape drawing 1: Plan
(Manual drawing)

Landscape drawing 2: Plan
(Mechanical drawing)

Plants

Plants constitute an important component of landscape drawing. A wide range of plant materials can be used in a landscape drawing, depending on the design and purpose of the drawing. The creation of plants involves the use of many different lines. Observe the step-by-step process of drawing plants such as ground covers, shrubs, and trees.

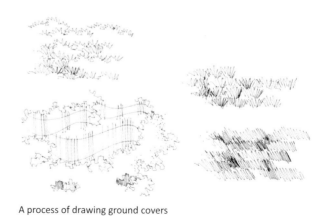

A process of drawing ground covers

Step-by-step process of drawing shrubs

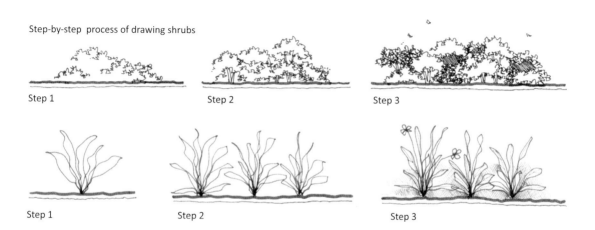

Step 1 Step 2 Step 3

Step 1 Step 2 Step 3

Step-by-step process of drawing a tree

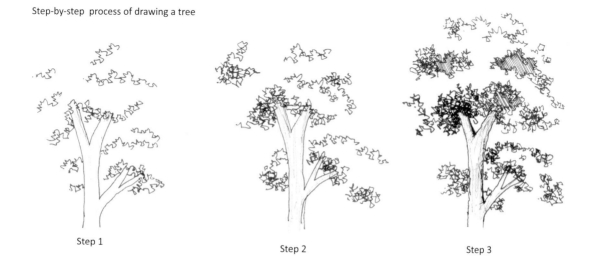

Step 1 Step 2 Step 3

Types of Trees

There are many different types of trees that can be drawn. Designers need to be creative in shaping the characteristics of trees. Here are a few examples of tree compositions viewed from an elevated point. The compositions are formed using different types of lines and line thicknesses.

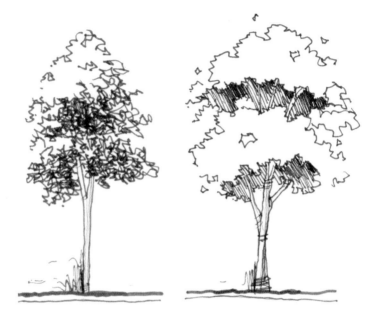

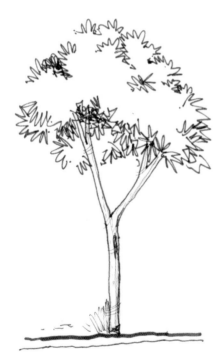

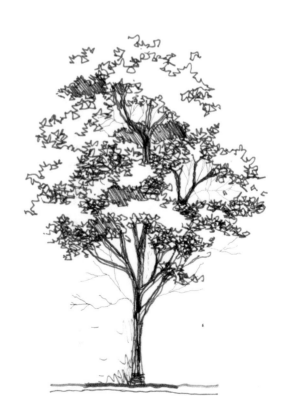

Example 1: Different types of tree compositions and elements are used in landscape drawings

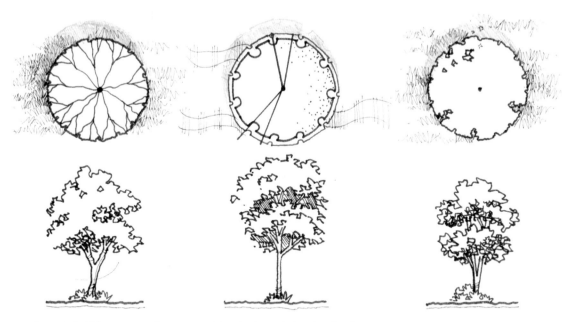

Example 2: Different types of tree compositions in plan and elevation sketches

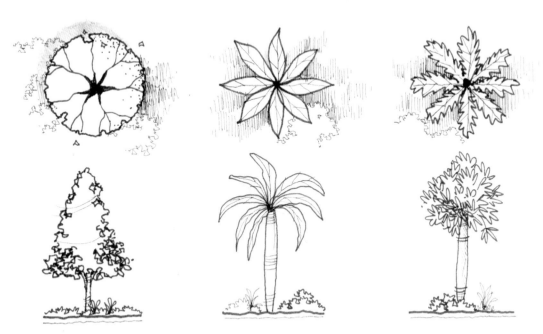

Example 3: Different types of tree compositions in plan and elevation sketches

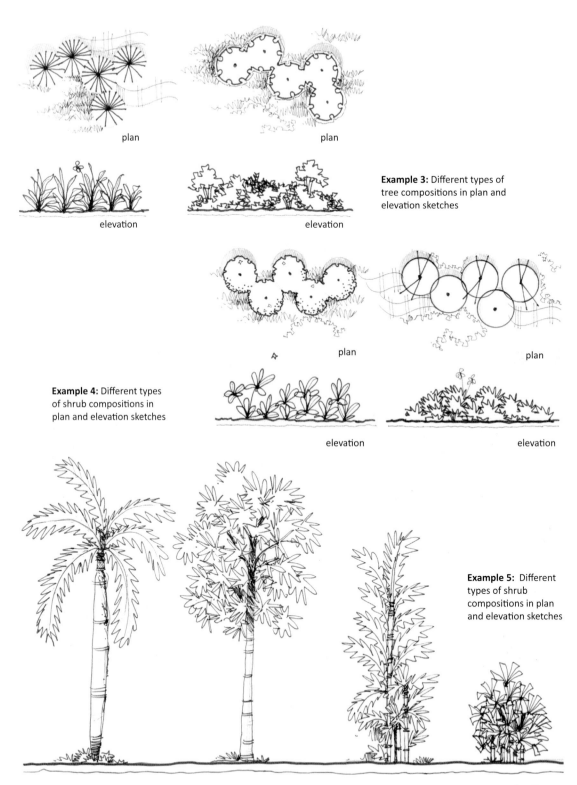

plan

plan

Example 3: Different types of tree compositions in plan and elevation sketches

elevation

elevation

Example 4: Different types of shrub compositions in plan and elevation sketches

plan

plan

elevation

elevation

Example 5: Different types of shrub compositions in plan and elevation sketches

elevation

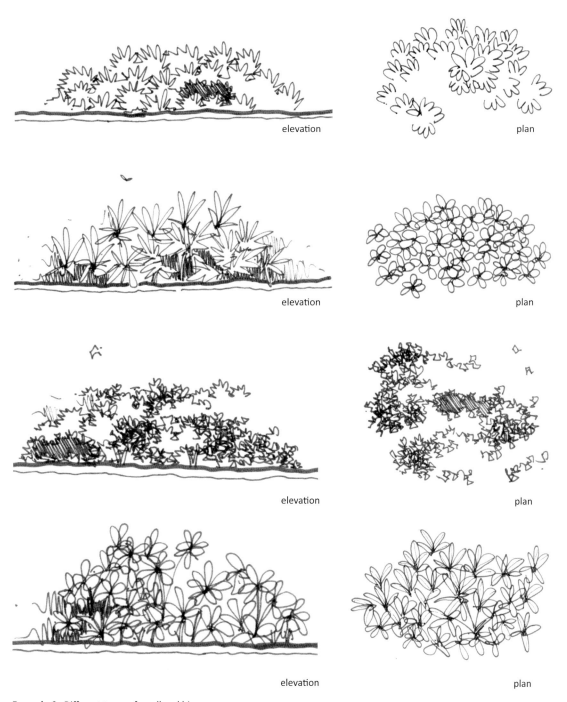

elevation

plan

elevation

plan

elevation

plan

elevation

plan

Example 6: Different types of small and big palm tree compositions in elevation sketches

115

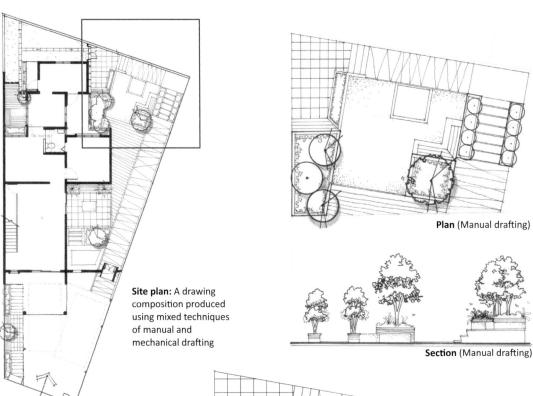

Site plan: A drawing composition produced using mixed techniques of manual and mechanical drafting

Plan (Manual drafting)

Section (Manual drafting)

Landscape Drawings Compositions

Landscape drawings can be produced using manual or mechanical drafting. Both types of drafting have their own strengths and characters in visualising design ideas and compositions.

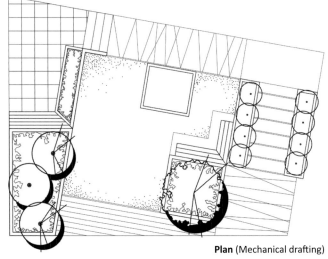

Plan (Mechanical drafting)

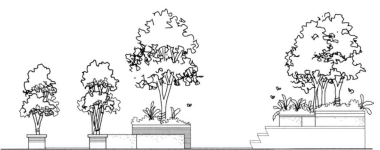

Section (Mechanical drafting)

Plan (Manual drafting)

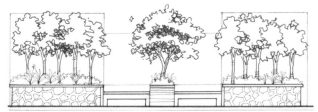

Section (Manual drafting)

In both manual and mechanical drafting, it is important to select the appropriate line types and line thicknesses to produce good drawing compositions. Observe the two sets of landscape drawings here that use both manual and mechanical drafts. Both sets of drawings selected almost the same line types and line thicknesses and the results are excellent drawing compositions.

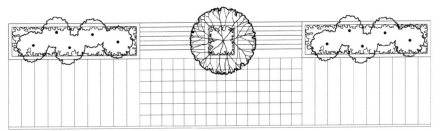

Plan (Mechanical drafting)

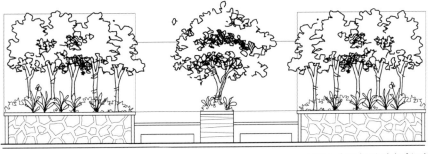

section (mechanical drafting)

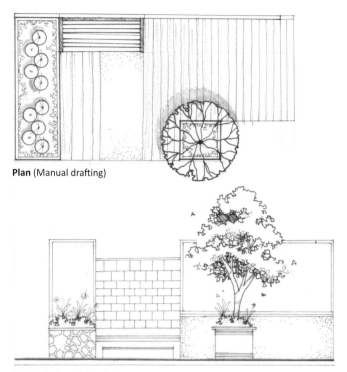

Plan (Manual drafting)

Section (Manual drafting)

These are examples of landscape drawings using both manual and mechanical drafting.
Both drawings have their own characters and unique visual outputs but they still adhere to the same drawing principles of appropriate and varying line types and line thicknesses.

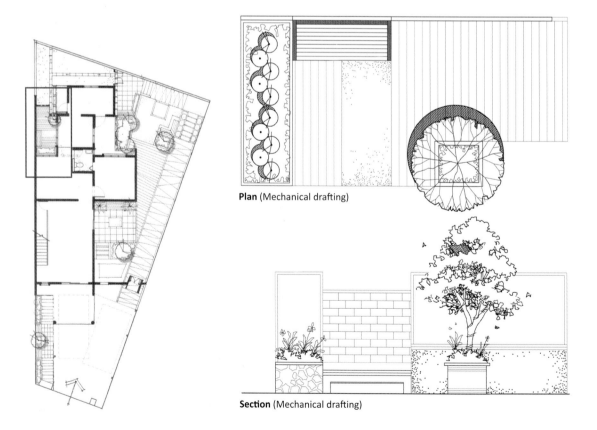

Plan (Mechanical drafting)

Section (Mechanical drafting)

Plan (Manual drafting)

Plan (Mechanical drafting)

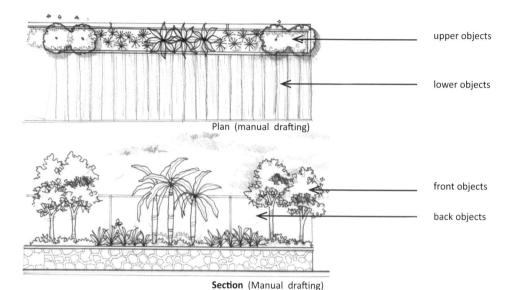

Plan (manual drafting)

upper objects

lower objects

front objects

back objects

Section (Manual drafting)

The position of any object in a landscape drawing determines the line thickness of that object. Usually, objects positioned in front or above are rendered with thicker lines compared to objects placed to the back or lower. Observe the examples given. In both the plan and section drawings, the principle of line thicknesses is applied.

Plan and Section (Mechanical drafting)

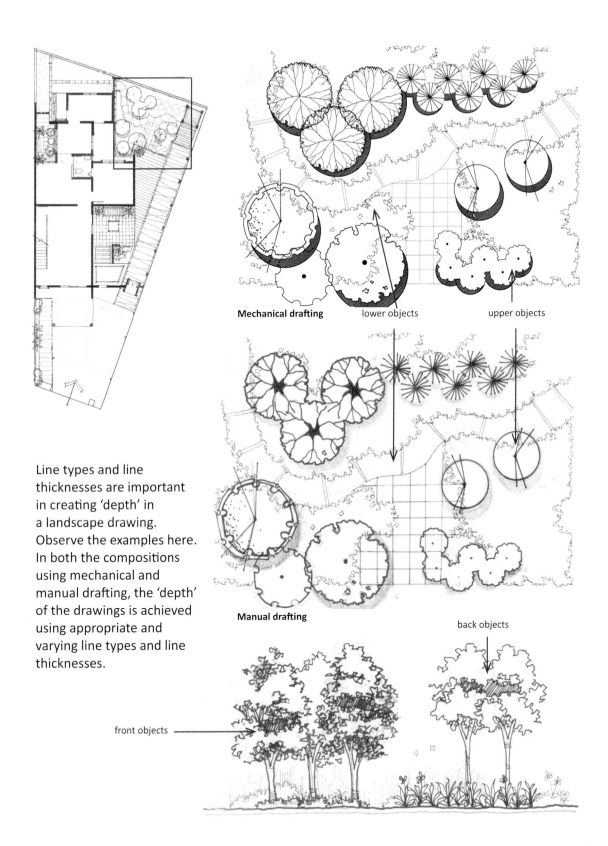

Mechanical drafting lower objects upper objects

Manual drafting

Line types and line thicknesses are important in creating 'depth' in a landscape drawing. Observe the examples here. In both the compositions using mechanical and manual drafting, the 'depth' of the drawings is achieved using appropriate and varying line types and line thicknesses.

back objects

front objects

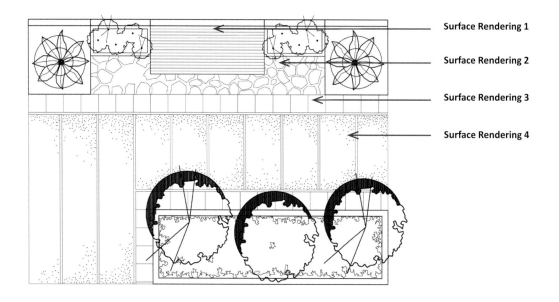

Surface Rendering 1

Surface Rendering 2

Surface Rendering 3

Surface Rendering 4

Another important aspect of creating a good landscape drawing is rendering. Rendering is used to highlight object compositions, especially the materials or surfaces of these objects. Observe the two drawings here. There are a few rendering outputs in these drawing compositions.

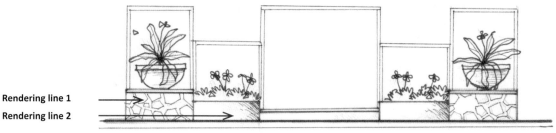

Rendering line 1

Rendering line 2

Section (Manual drafting)

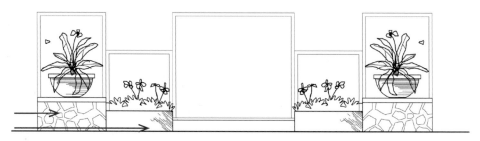

Rendering line 1

Rendering line 2

Section (Mechanical drafting)

4.2.5 Human Figure Drawings

The human figure is an important subject in design drawing. Human figures are used to represent the scale of humans to the objects in a design drawing. There are a variety of human figure styles that are applicable to a design presentation, such as real human forms, cartoon figures, and anime figures. Designers need to explore the potential that different human figure styles can offer in a design drawing presentation. There are also numerous ways to present human figures in a design drawing using colours, outlines, and black and white characters.

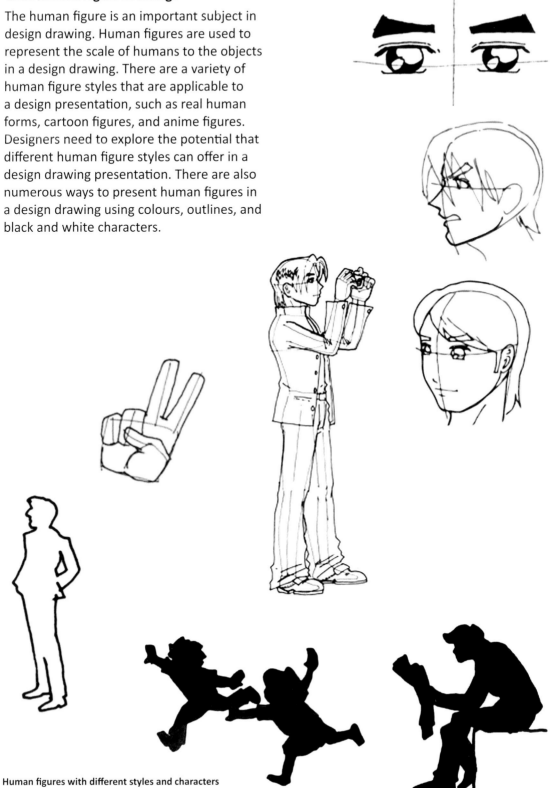

Human figures with different styles and characters

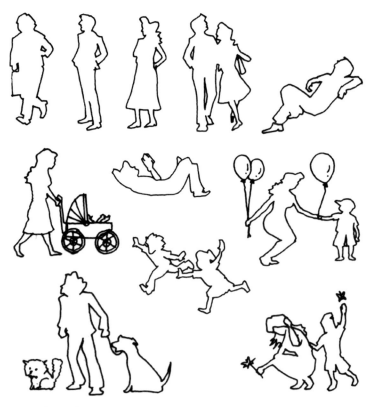

Here are two sets of human figure characters that employ outlines and solid colour. The figures in solid colour are more outstanding compared to the figures with outlines. Solid colour figures are usually employed for strong spatial impact in a composition. Figures with outlines, on the other hand, highlight the space itself, rather than the figures. Observe these characteristics of solid colour figures and figures with outlines in the examples given on the next page.

Human figure characters with outlines

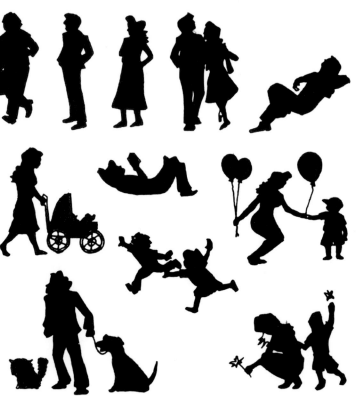

Human figure characters in solid colours

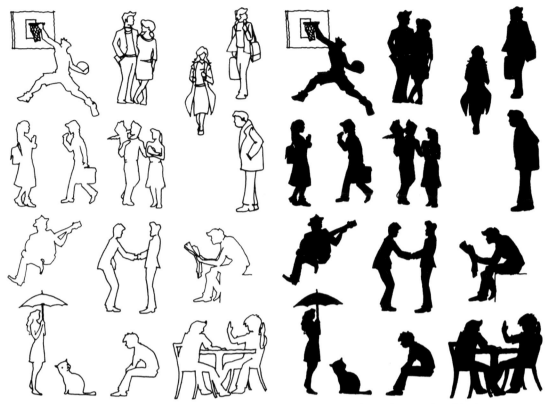

Human figure characters with outlines **Human figure characters in solid colours**

Human figure characters with outlines complement the space in a composition.

Human figure characters in solid colours appear more outstanding compared to the space in a composition.

Putting colours in a design composition is an interesting process. Colours give more visual input to the design ambience of a composition. By adding human figure characters, a sense of scale is lent to the space in a composition. Colours and human figures thus play important roles in producing good design compositions.

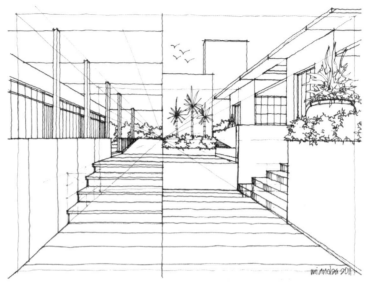

Perspective drawing with no colour or human figures

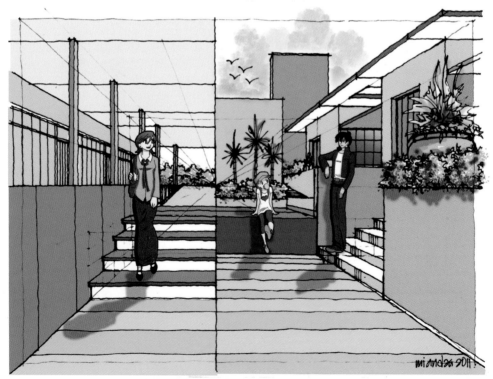

Colours and human figures in a perspective drawing

Here are two more examples of how colours and human figures are important in making a perspective drawing come alive.

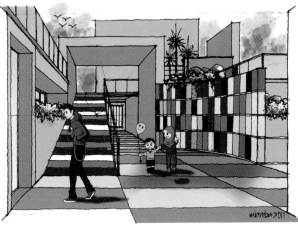

Example 1

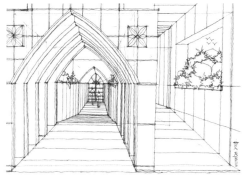

Two perspective drawing compositions that are with and without colours and human figures

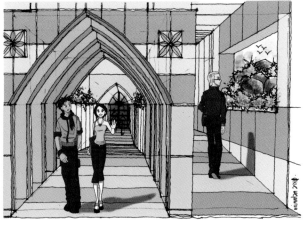

Example 2

Here, an example demonstrates the functions of human figures and colours in making perspective drawing more interesting. In this example, human figures and colours highlight the ambience of the space created.

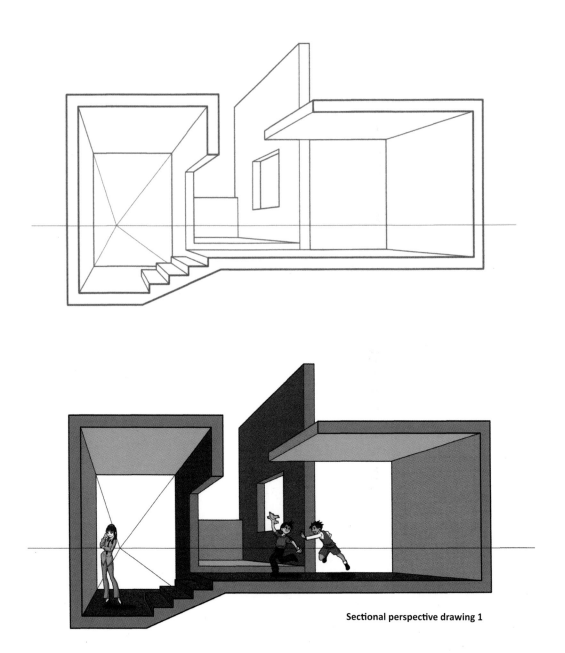

Sectional perspective drawing 1

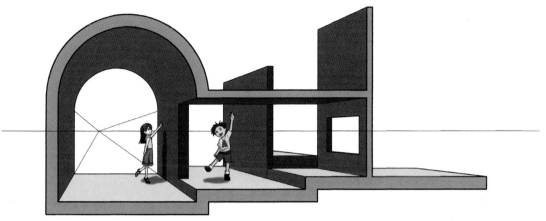

Sectional perspective drawing 2

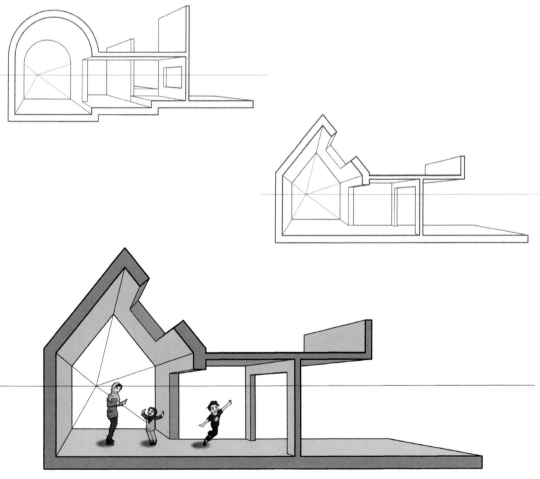

Sectional perspective drawing 3

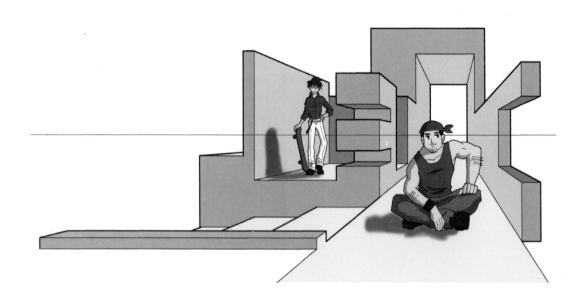

One-point perspective drawing

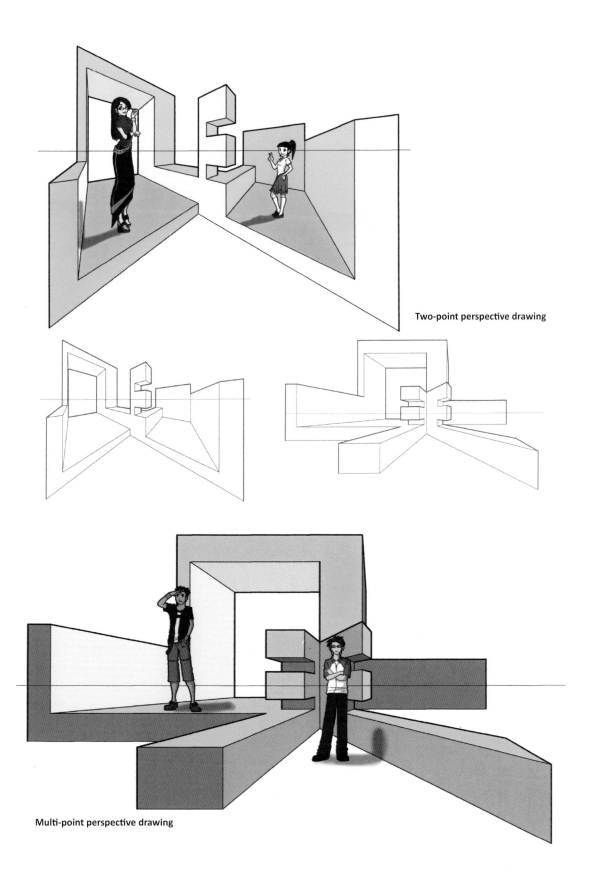

Two-point perspective drawing

Multi-point perspective drawing

4.2.6 Vehicle Drawings

Vehicles are important elements in presentation drawings that involve man-made environments, especially urban environments. Many techniques can be used to draw vehicles. One technique is the use of an imaginary box. This technique can be employed either in two dimensional or three dimensional drawing compositions. The imaginary box is an interesting and easy technique that can be used to compose view angles for vehicle compositions. Observe the examples in this section to further understand how the imaginary box technique can be used in vehicle compositions.

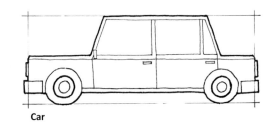

Car

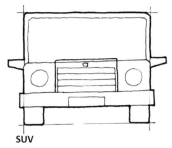

SUV

Examples of vehicles constituting a car, a Sports Utility Vehicle (SUV), and a motorcycle drawn in two dimensional compositions

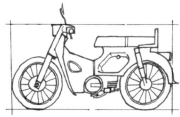

Motorcycle

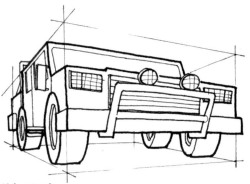

Pickup truck

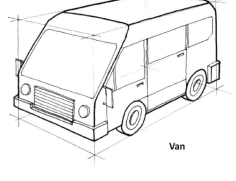

Van

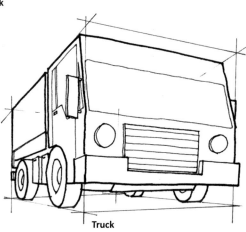

Truck

Examples of vehicles constituting a pickup truck, a van, and a truck in three dimensional compositions

132

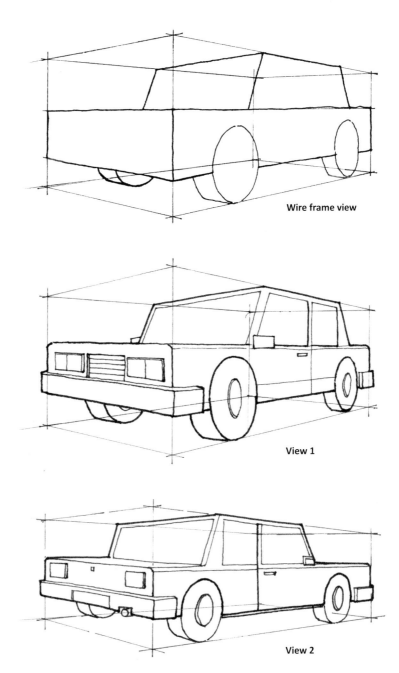

Wire frame view

View 1

View 2

This example demonstrates the process of drawing a car guided by an imaginary box. This process begins with drawing the wire-frame of the car and then proceeding with the detailing of the car.

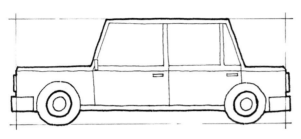

Car drawing : View 1 (2D)

Motorcycle drawing: View 1 (2D)

Car drawing: View 1 (3D)

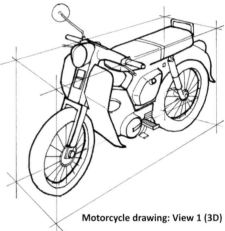

Motorcycle drawing: View 1 (3D)

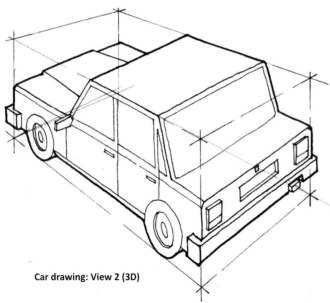

Car drawing: View 2 (3D)

A Car and A Motorcycle
These are some examples of car and motorcycle drawings done from different view angles.

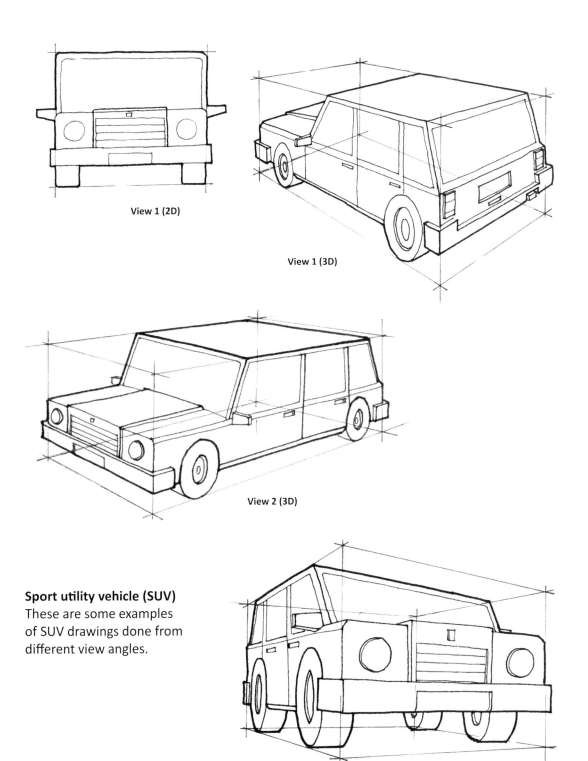

View 1 (2D)

View 1 (3D)

View 2 (3D)

Sport utility vehicle (SUV)
These are some examples
of SUV drawings done from
different view angles.

View 3 (3D)

Pickup Truck

These are some examples of pickup truck drawings done from different view angles.

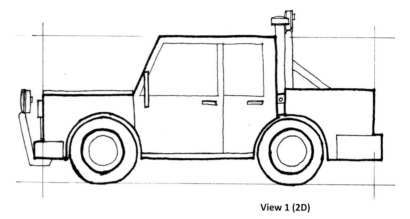

View 1 (2D)

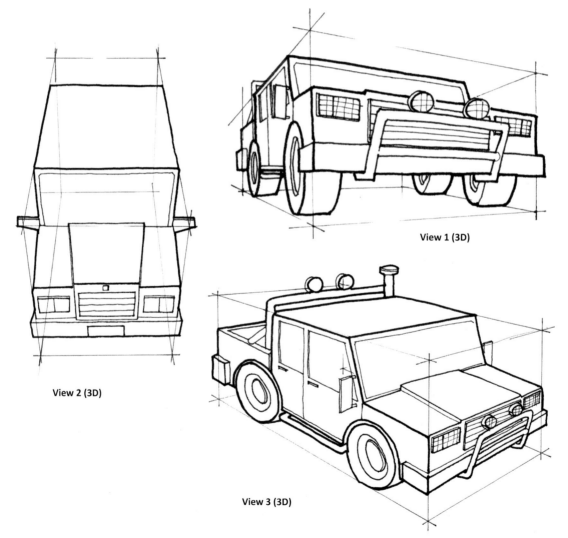

View 1 (3D)

View 2 (3D)

View 3 (3D)

Van

These are some examples of van drawings done from different view angles.

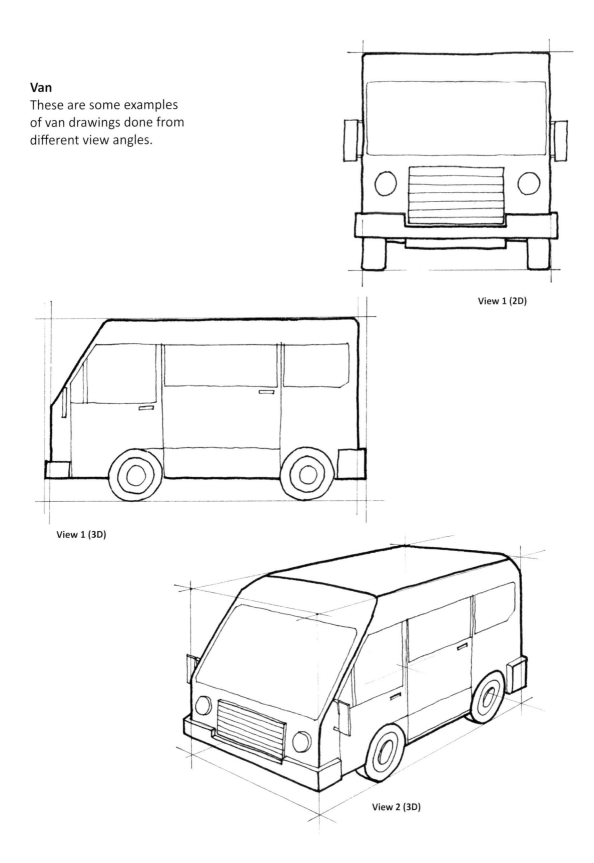

View 1 (2D)

View 1 (3D)

View 2 (3D)

Light truck

These are some examples
of light truck drawings done
from different view angles.

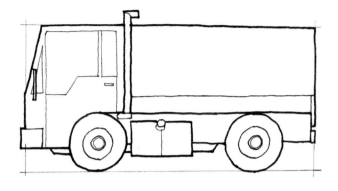

View 1 (2D)

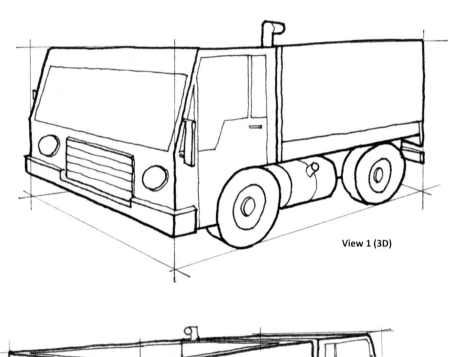

View 1 (3D)

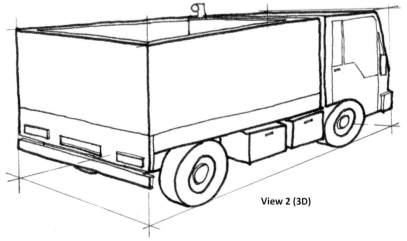

View 2 (3D)

Truck

These are some examples of truck drawings done from different view angles.

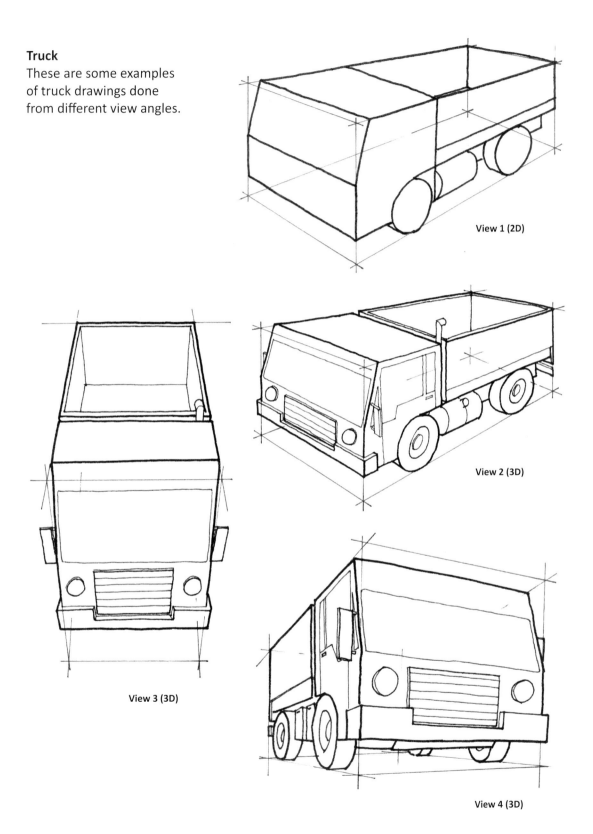

View 1 (2D)

View 2 (3D)

View 3 (3D)

View 4 (3D)

Bus

These are some examples of bus drawings done from different view angles.

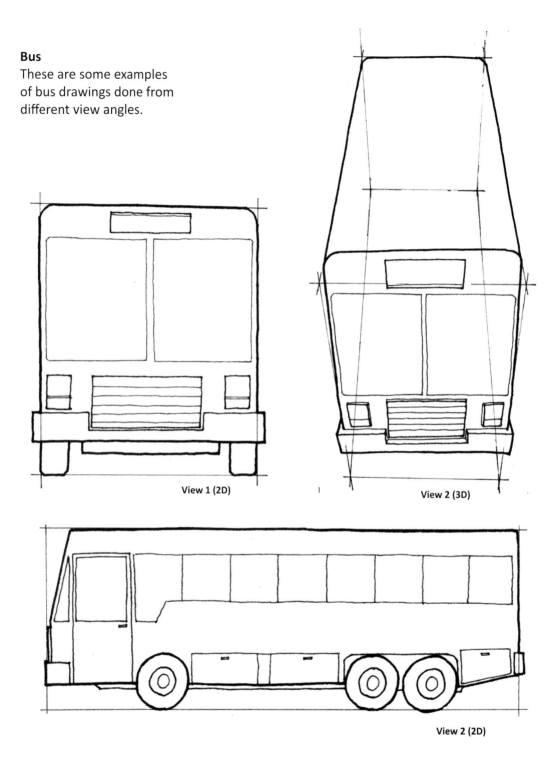

View 1 (2D)

View 2 (3D)

View 2 (2D)

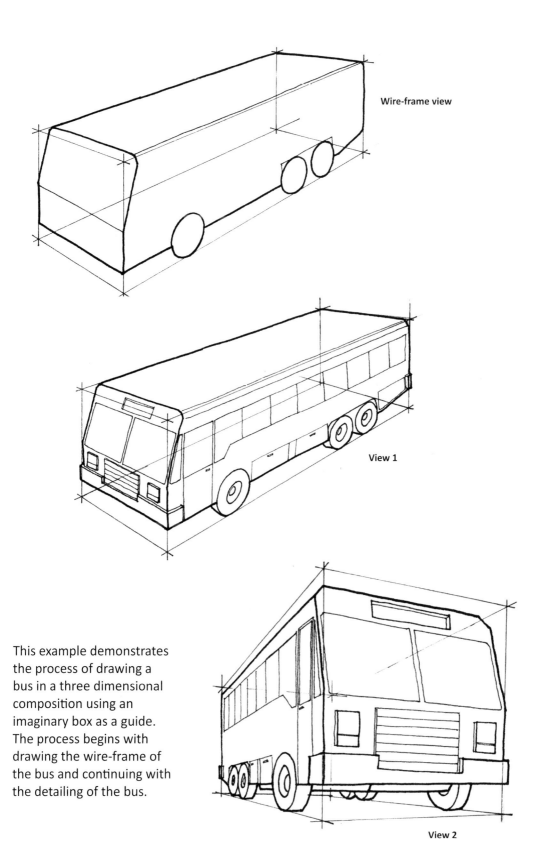

Wire-frame view

View 1

This example demonstrates the process of drawing a bus in a three dimensional composition using an imaginary box as a guide. The process begins with drawing the wire-frame of the bus and continuing with the detailing of the bus.

View 2

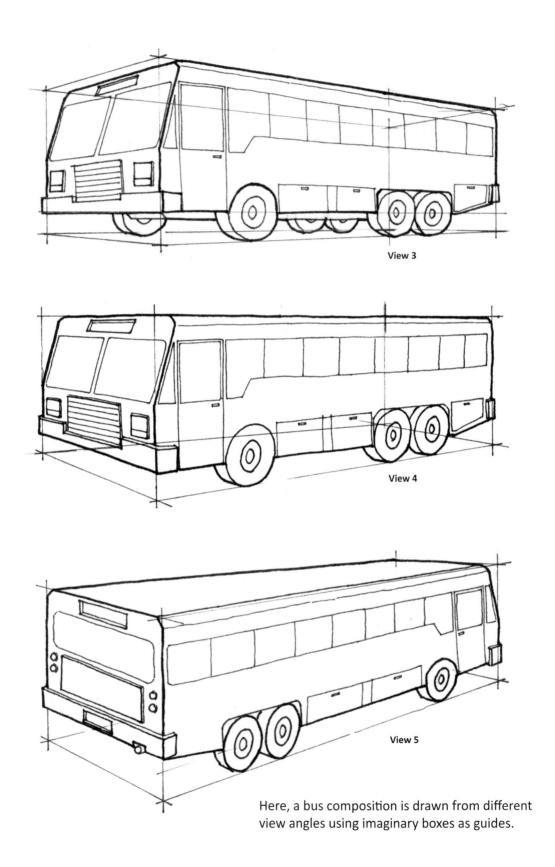

View 3

View 4

View 5

Here, a bus composition is drawn from different view angles using imaginary boxes as guides.

A two dimensional sketch composition of a car parked by a house

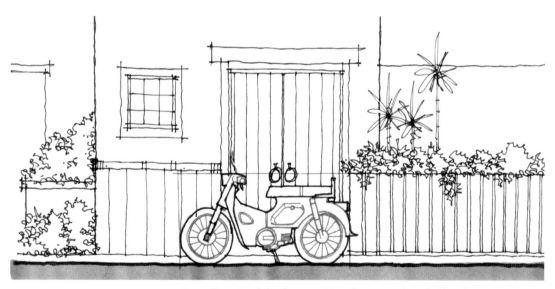

A two dimensional sketch composition of a motorcycle parked by a house and a garden

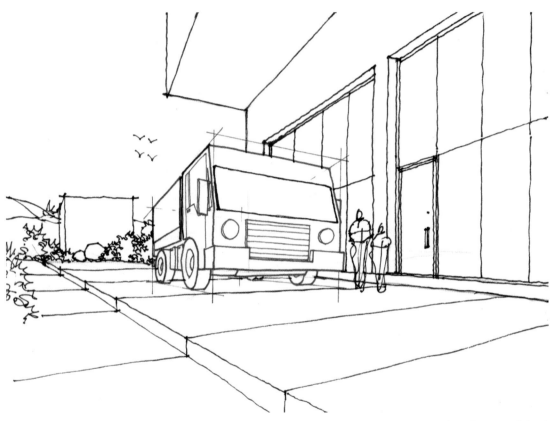

A three dimensional sketch
composition of truck parked
by a building

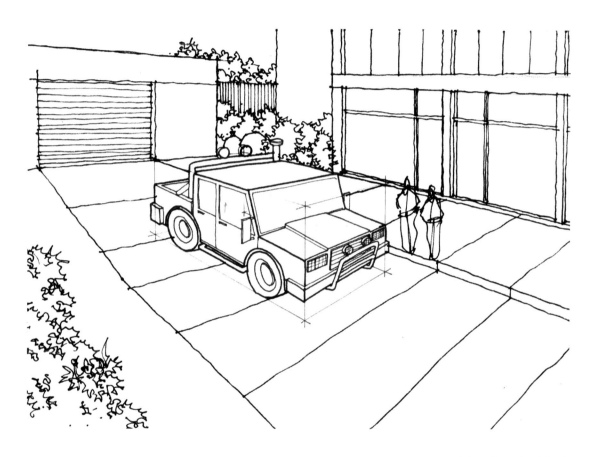

A three dimensional sketch
composition of a pickup truck
parked in front of a garage

5.0 Presentation Drawing

There are innumerable ways to produce a good visual presentation drawing. It is important to be creative in order to produce an excellent one. This can be achieved through a variety of visual communication media, such as drawings and sketches. What sets a good presentation drawing apart is its ability to successfully deliver visual information on design ideas or related information to a target audience.

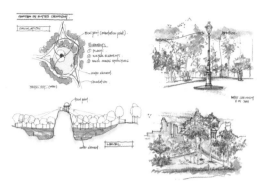

Example 2: Presentation drawing composition 2

As presentation drawing evolves from manual to mechanical drafting and digital presentation, the production processes of these drawings also change. With the advancement of visualization tools software, presentation drawings are prepared using a combination of manual and computerised processes. Layout arrangements for presentation drawing can be printed for display using appropriate printers, plotters, or even electronically projected onto a screen.

However, there is one thing that remains a constant in presentation drawing: the principles of good graphics. This chapter discusses some issues on presentation drawing formatting that must be understood. A few samples of presentation drawings are used throughout this chapter to illustrate key principles behind presentation drawing.

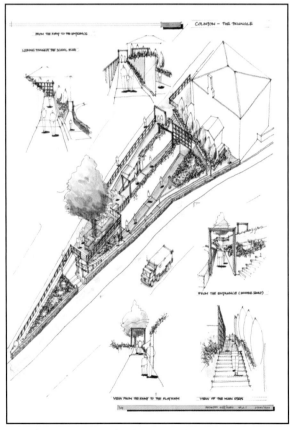

Example 1: Presentation drawing composition 1

5.1 Presentation Drawings Compositions

A good presentation drawing must have a good combination of lettering layout, graphic images and graphic symbols. In order to achieve this, creativity and basic knowledge on formatting is basic requirement. Presentation drawing format consists of two main portions: Layout and typography. The layout of a drawing includes thinking about its paper size, margins, letter spacing and arrangement, graphic images and graphic symbols. Typography refers to the size, font style, and the positioning of fonts in a drawing.

Here is some information related to presentation drawing format that designers need to be aware of and understand before starting a presentation drawing.

The presentation drawing format we suggest is as follows:

i. **Layout**

 Paper Size: It is important to know the required size and orientation of a presentation drawing to ensure that your graphic images, lettering and symbols fit with the proposed size of the drawings. The size requirements of presentation drawings are unique to each individual project.

 Paper Orientation: Presentation drawings can be in landscape or portrait format.

 Paper Margin and spacing: Margins and letter spacing should fit well with the lettering, graphic images, graphic symbol arrangement and overall concept of the presentation drawing.

ii. **Typography**

The typography of a presentation should also be related to the overall presentation concept. The font size and types selected should be legible to your target audience.

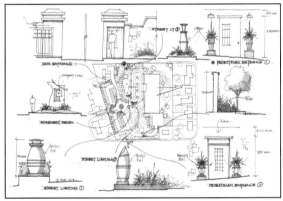

Presentation drawing in landscape format

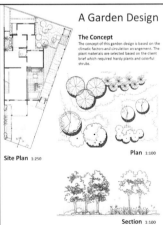

Presentation drawing in portrait format

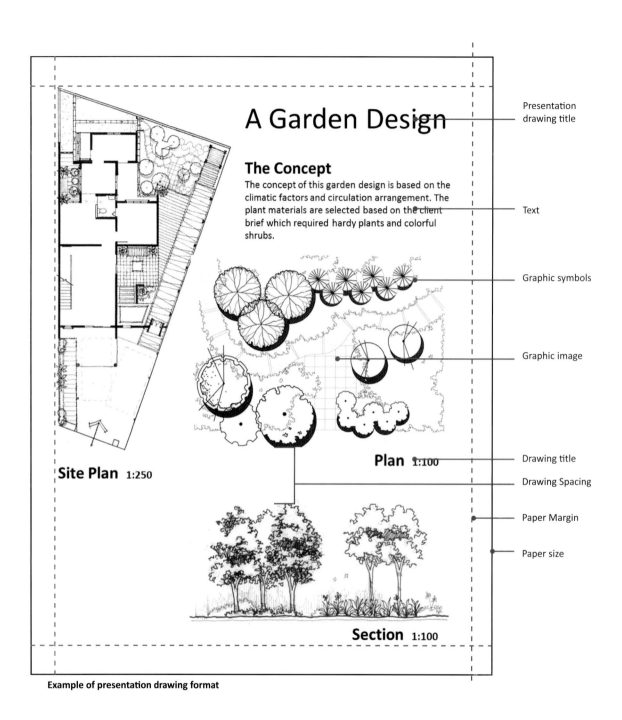

A Garden Design

The Concept

The concept of this garden design is based on the climatic factors and circulation arrangement. The plant materials are selected based on the client brief which required hardy plants and colorful shrubs.

Site Plan 1:250

Plan 1:100

Section 1:100

Presentation drawing title

Text

Graphic symbols

Graphic image

Drawing title

Drawing Spacing

Paper Margin

Paper size

Example of presentation drawing format

5.2 Basic Presentation Drawing Components

The three main components of presentation drawing are:

a. Graphic images
b. Lettering
c. Graphic symbols

Graphic images constitute the main component in a presentation drawing and many types are used. Some examples include concept drawings, plans, sections, elevations, three-dimensional drawings, pictures and others. The ability to choose and produce appropriate graphic images is advantageous as it allows you to produce a quality presentation drawing composition.

Lettering is used to communicate information that cannot be delivered through graphic images or symbols. This usually includes explanations related to project briefs, drawing scale information, perspective view information, drawing titles, legends and text.

Graphic symbols refer to drawing symbols such as north-pointing arrows, scale bars, and typography symbols. The function of graphic symbols is to strengthen and simplify a presentation drawing, as well as visual information contained in graphic images.

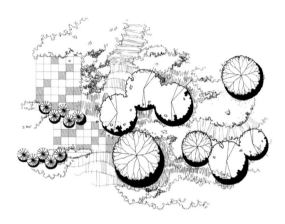

Examples of lettering, graphic images and graphic symbols

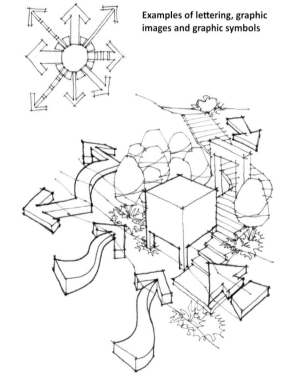

149

5.2.1 Images.

Images for a presentation drawing can be in the form of drawings, pictures or diagrams. Creativity and exploration are required in order to get interesting composition and visual outputs. The images used on any presentation drawing should be able to clearly and efficiently communicate design ideas to an audience.

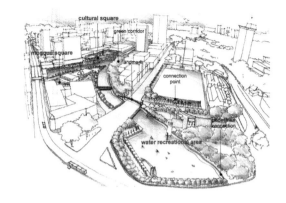

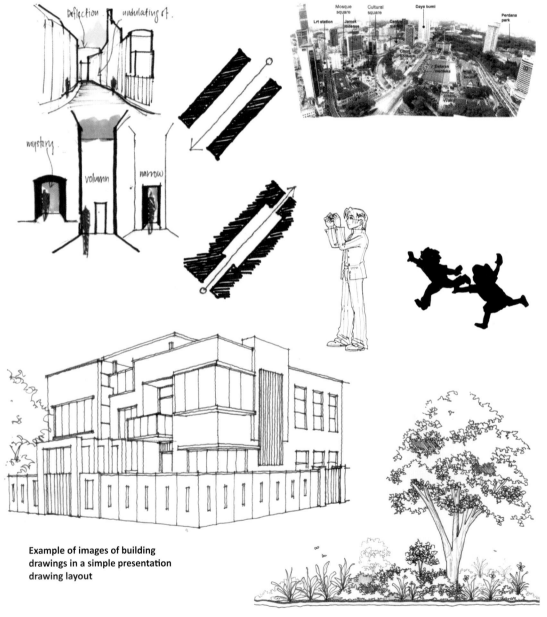

Example of images of building drawings in a simple presentation drawing layout

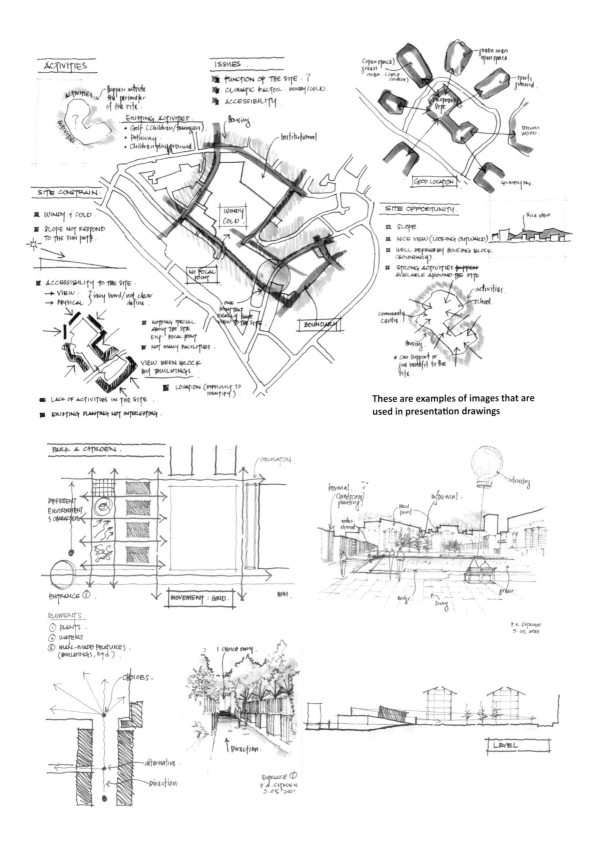

These are examples of images that are used in presentation drawings

151

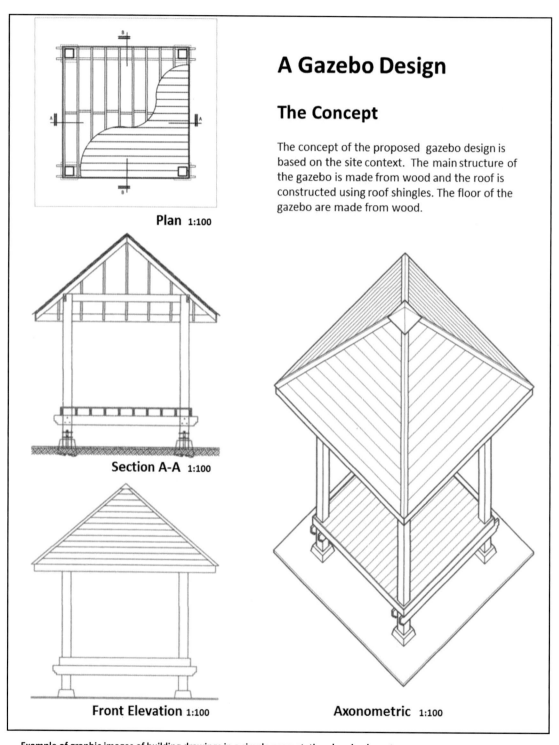

A Gazebo Design

The Concept

The concept of the proposed gazebo design is based on the site context. The main structure of the gazebo is made from wood and the roof is constructed using roof shingles. The floor of the gazebo are made from wood.

Plan 1:100

Section A-A 1:100

Front Elevation 1:100

Axonometric 1:100

Example of graphic images of building drawings in a simple presentation drawing layout

5.2.2 Graphic symbols

There are many types of graphic symbols in a presentation drawing. The main function of graphic symbols is to simplify or inform without using words. An example would be the use of a north-pointing arrow in a site plan. Graphic symbols also help to strengthen the visual information of graphic images.

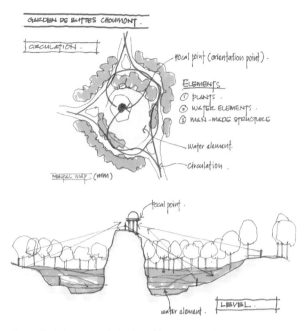

Example 1: Arrows and simple red lines are used to show view angles and 'connection' in graphic images.

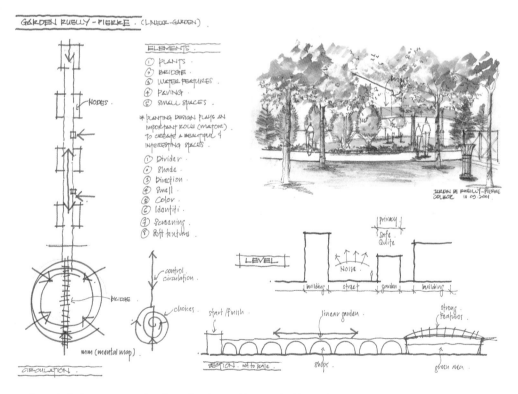

Example 2: Arrows are used to show direction and 'connection' in graphic images

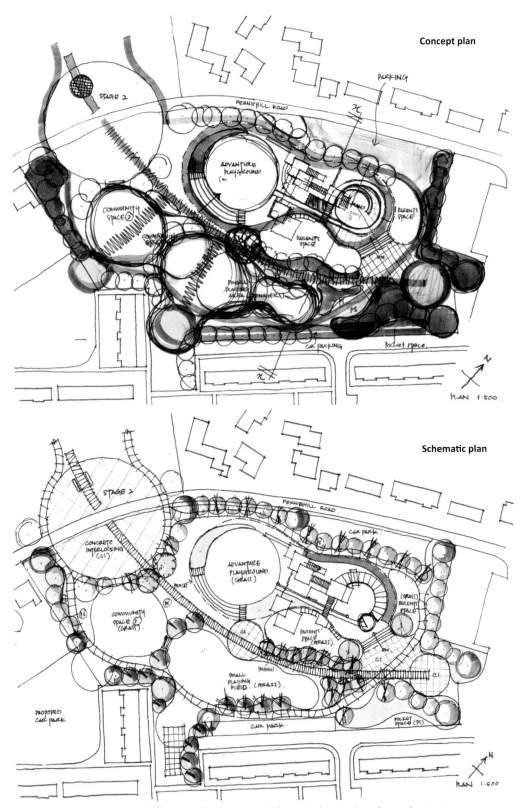

Example 3: A few graphic symbols are used in concept and schematic plans, such as the north-pointing arrow, simple zigzag lines, cross section lines and plant material symbols

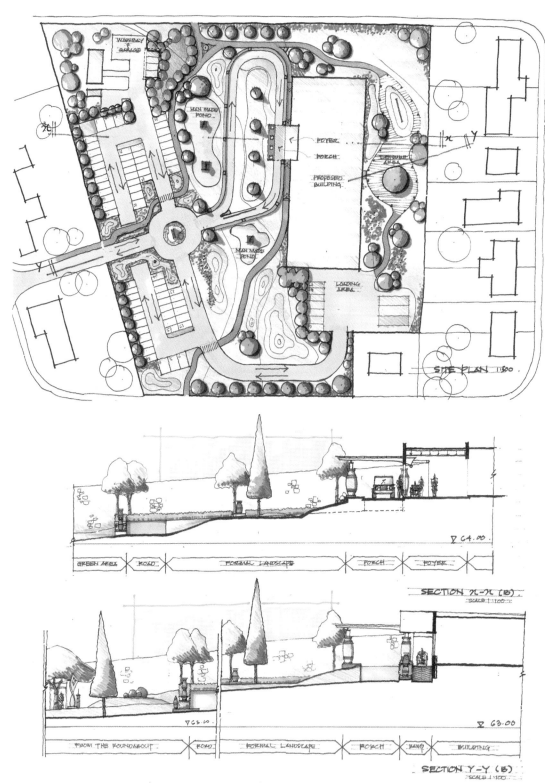

Example 4: There are also graphic symbols used to indicate positions of cross sections in a drawing composition, while arrows are used to show circulation on the site

5.2.3 Lettering

lettering for drawing titles, legends and text within a presentation drawing. It is important to study the character of each font before applying it. In the examples of fonts given, each font has its unique character and visual output. The selection of fonts needs to be done carefully to match the overall concept of the presentation drawing.

A B C D E F G H I
Aharoni

A B C D E F G H I
Times New Roman

A B C D E F G H I
Algerian

A B C D E F G H I
CountryBlueprint

A B C D E F G H I
Arial Unicode MS

A B C D E F G H I
Broadway

A B C D E F G H I
Bradley Hand ITC

A B C D E F G H I
Brush Script MT

A B C D E F G H I
CommercialScript BT

Examples of fonts

**Gazebo
design**

Example building drawing 1: Visual output of a presentation drawing using 'Font type A'

The examples of presentation drawings given here range from building to landscape drawings. The fonts used in these layouts contribute to the character of the composition as a whole. Some fonts have the ability to create a formal visual look while others may appear to be more informal. Thus it is important to choose an appropriate font to produce a presentation drawing that is effective in its communication.

Example building drawing 2: Visual output of a presentation drawing using 'Font type B'

Example building drawing 3: Visual output of a presentation drawing using font 'type C'

Example building drawing 4: Visual output of a presentation drawing using 'Font type D'

Example building drawing 5: Visual output of a presentation drawing using font 'type E'

Example landscape drawing 1: Visual output of a presentation drawing using 'Font type A'

Example landscape drawing 2: Visual output of a presentation drawing using 'Font type B'

Example landscape drawing 3: Visual output of a presentation drawing using 'Font type C'

Example landscape drawing 4: Visual output of a presentation drawing using 'Font type D'

Example building drawing 1: Visual output of a presentation drawing using 'Font size 1'

Font Size

It is essential that the appropriate font size is selected based on the scale and proportion of graphic images used and the overall presentation drawing. The following are some examples of presentation drawings using different font sizes. Note the varying visual impacts of the different font sizes on the overall presentation drawing.

A B C D E F G H I

A B C D E F G H I

A B C D E F G H I

A B C D E F G H I

A B C D E F G H I

A B C D E F G H I

Examples of font sizes

Gazebo
design

Example building drawing 2: Visual output of a presentation drawing using 'Font size 2'

Gazebo
design

Example building drawing 3: Visual output of a presentation drawing using 'Font size 3'

Gazebo
design

Example building drawing 4: Visual output of a presentation drawing using 'Font size 4'

Gazebo
design

Example building drawing 5: Visual output of a presentation drawing using 'Font size 5'

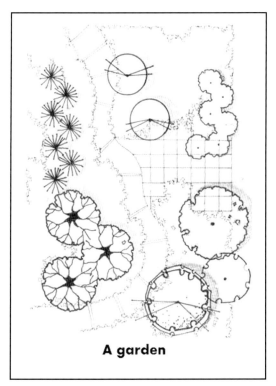

A garden

Example landscape drawing 1: Visual output of a presentation drawing using 'Font size 1'

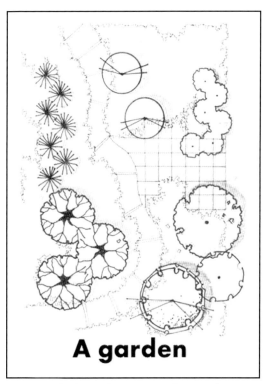

A garden

Example landscape drawing 1: Visual output of a presentation drawing using 'Font size 2'

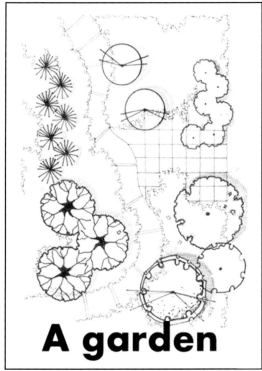

A garden

Example landscape drawing 1: Visual output of a presentation drawing using 'Font size 3'

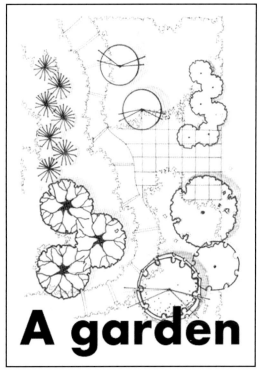

A garden

Example landscape drawing 1: Visual output of a presentation drawing using 'Font size 4'

Font colour

Font colours can evoke certain emotions or promote messages, hence influencing the overall visual output of a presentation drawing. The colour red, for example, suggests heat, while blue conversely evokes coolness. Green, on the other hand, symbolises nature. Hence, it is important to know what a colour might represent or arouse in a potential viewer before selecting it for a presentation drawing. In the following examples, note how different font colours create and contribute a different feel to the overall drawing.

Example building drawing 1: Visual output of a presentation drawing using 'Font colour 1'

A B C D E F G H I

A B C D E F G H I

A B C D E F G H I

A B C D E F G H I

A B C D E F G H I

A B C D E F G H I

A B C D E F G H I

A B C D E F G H I

A B C D E F G H I

A B C D E F G H I

A B C D E F G H I

A B C D E F G H I

Different colors applied to the fonts

Example building drawing 2: Visual output of a presentation drawing using 'Font colour 2'

Example building drawing 3: Visual output of a presentation drawing using 'Font colour 3'

Example building drawing 4: Visual output of a presentation drawing using 'Font colour 4'

Example building drawing 5: Visual output of a presentation drawing using 'Font colour 5'

Example landscape drawing 1: Visual output of a presentation drawing using 'Font colour 1'

Example landscape drawing 2: Visual output of a presentation drawing using 'Font colour 2'

Example landscape drawing 3: Visual output of a presentation drawing using 'Font colour 3'

Example landscape drawing 4: Visual output of a presentation drawing using 'Font colour 4'

Example building drawing 1: Visual output of a presentation drawing using 'Font layout 1'

a

b

c

d

e

f

g

a b c d e f g

a b c d e f g a b c d e f g

Font layout

Each font layout in the examples given offers a different character and visual output to the overall presentation drawing composition. Creativity is needed in exploring whether a font layout suits the general design concept. The following examples illustrate how font layouts can contribute to the visuals of presentation drawings.

Gazebo design

Example building drawing 2: Visual output of a presentation drawing using 'Font layout 2'

Example building drawing 3: Visual output of a presentation drawing using 'Font layout 3'

Gazebo
design

Gazebo
design

Example building drawing 4: Visual output of a presentation drawing using 'Font layout 4'

Example building drawing 5: Visual output of a presentation drawing using font layout 5'

Example landscape drawing 1: Visual output of a presentation drawing using 'Font layout 1'

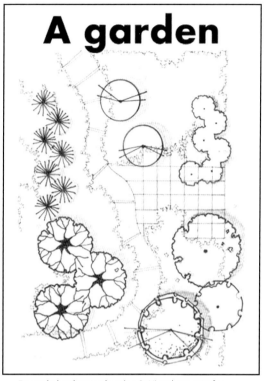

Example landscape drawing 2: Visual output of a presentation drawing using 'Font layout 2'

Example landscape drawing 3: Visual output of a presentation drawing using 'Font layout 3'

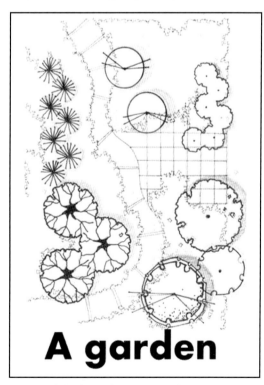

Example landscape drawing 4: Visual output of a presentation drawing using 'Font layout 4'

5.3 Presentation Drawings Layout

There is a multiplicity of ways that the layout of a presentation drawing can be used to deliver relevant information clearly and successfully. A few factors must be considered when preparing the layout of a presentation drawing, such as the concept of the layout and its design ideas or information and the availability of technology that can be used to produce the presentation drawing. Of course, you need to have a good grasp of the knowledge and skills involved in presentation drawing first, which involves things such as drawing compositions, selection of font type and size, colour scheme, presentation format.

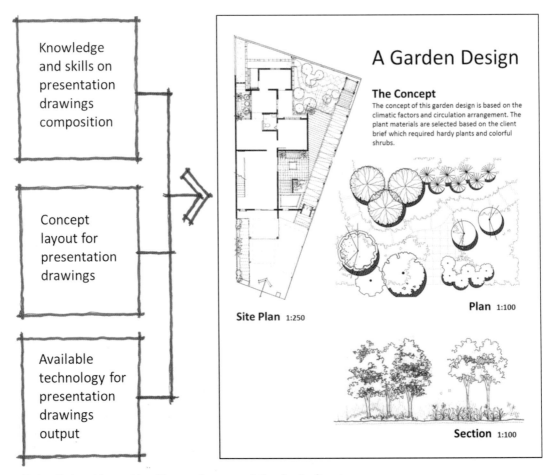

Factors that must be considered in preparing a presentation drawing layout

It is essential to have the ability to use, understand, and simplify design ideas for presentation drawings. This will help you to make your presentation drawings more interesting and allow you to convey design information effectively to your audience. In preparing your final presentation drawing layout, it is important to make sure that the presentation drawings are done well. This principle applies whether you produce the drawings manually or with computer software. If you use computer software to produce your drawings and these drawings need to be printed out, you must ensure that the printer or plotter is compatible with the software you are using. In this section, a few selected examples of presentation drawings are shown. These examples demonstrate some of the ideas that can be used in producing presentation drawing layouts.

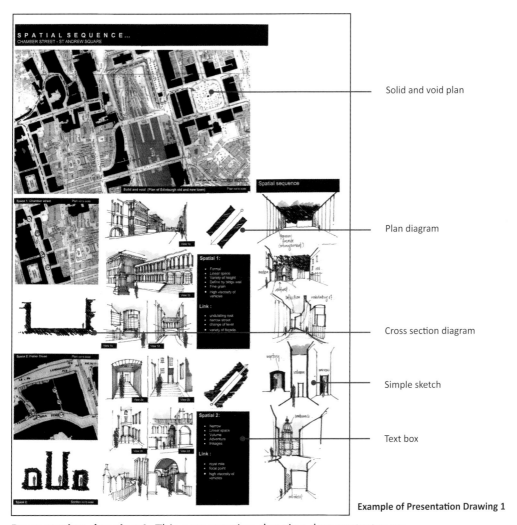

Example of Presentation Drawing 1

Presentation drawing 1: This presentation drawing demonstrates an analysis of spaces in an urban area. The main graphic images used are the solid and void plans, cross section and plan diagrams, simple perspective sketches and text.

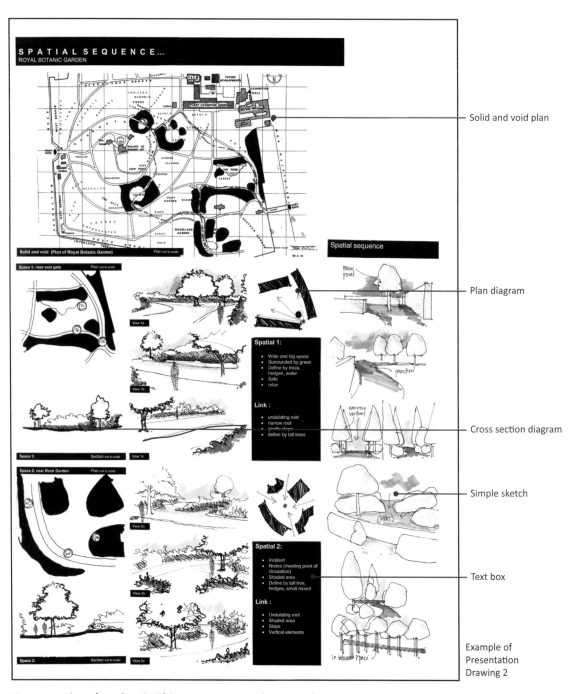

Solid and void plan

Plan diagram

Cross section diagram

Simple sketch

Text box

Example of Presentation Drawing 2

Presentation drawing 2: This presentation drawing demonstrates an analysis of spaces in a landscape setting, such as a park. The main graphic images used are the solid and void plans, cross section and plan diagrams, simple perspective sketches and text.

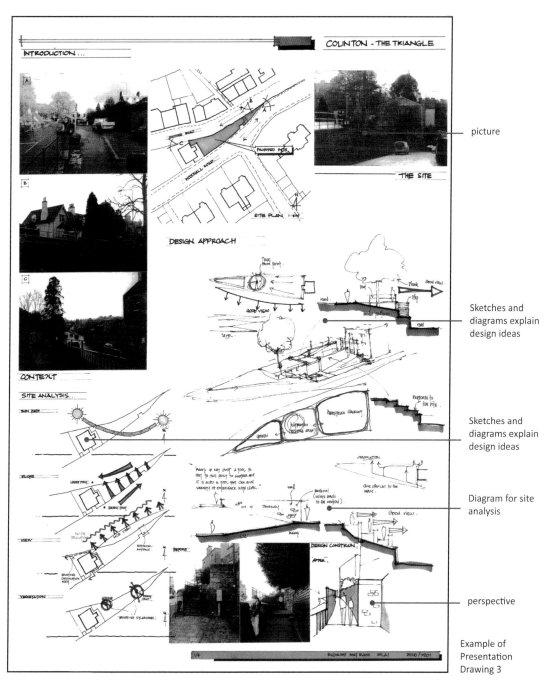

picture

Sketches and diagrams explain design ideas

Sketches and diagrams explain design ideas

Diagram for site analysis

perspective

Example of Presentation Drawing 3

Presentation drawing 3: This presentation drawing demonstrates an analysis of a site located in a village. Graphic images, such as plan and sectional diagrams as well as simple perspective sketches and pictures, are used to explain the condition of the site. Letterings, such as drawing titles and text, are used to complete the visual explanation provided by the graphic images.

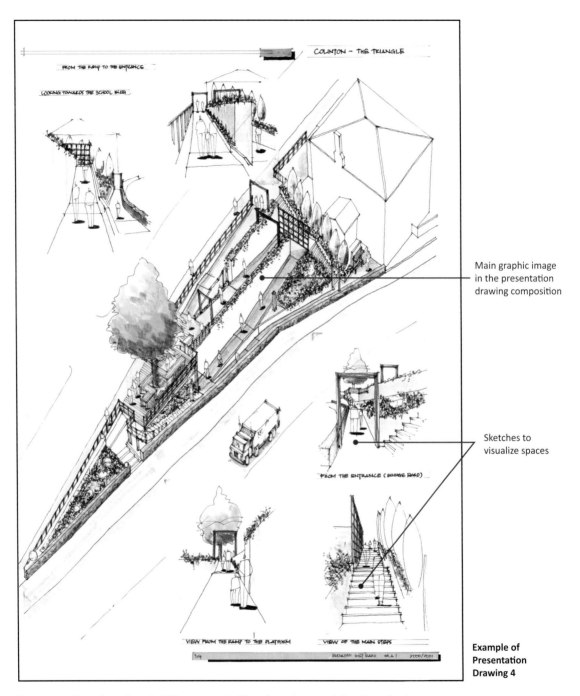

Main graphic image in the presentation drawing composition

Sketches to visualize spaces

Example of Presentation Drawing 4

Presentation drawing 4: This presentation drawing explains the design proposal for a site located in a village. The graphic images used are axonometric drawings and perspective sketches. Letterings, such as drawing titles and text, are used to strengthen the visual explanation provided by the graphic images.

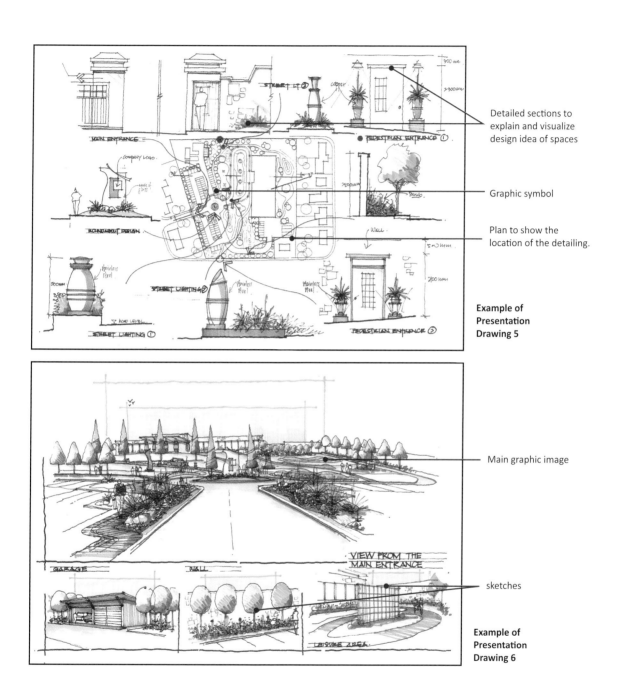

Detailed sections to explain and visualize design idea of spaces

Graphic symbol

Plan to show the location of the detailing.

Example of Presentation Drawing 5

Main graphic image

sketches

Example of Presentation Drawing 6

Presentation drawing 5: This presentation drawing explains and visualises the detailed design of a site. The graphic images used are section drawings and a plan. Graphic symbols, such as arrows and dots, connect the section drawings to the plan.

Presentation drawing 6 : This presentation drawing explains and visualises the detailed design of a site using perspective sketches and lettering.

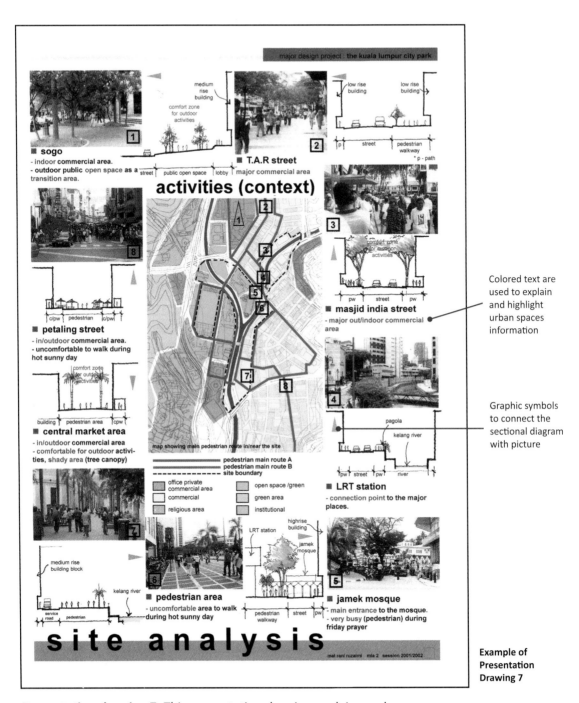

Colored text are used to explain and highlight urban spaces information

Graphic symbols to connect the sectional diagram with picture

Example of Presentation Drawing 7

Presentation drawing 7: This presentation drawing explains and visualises the analysis of space in an urban area. Sectional diagrams, pictures, and an urban area map supported with graphic symbols and letterings are used to explain the findings.

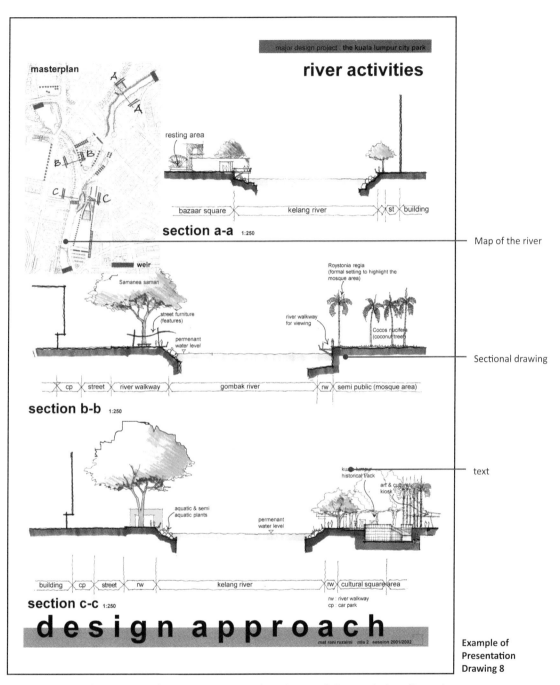

Map of the river

Sectional drawing

text

Example of
Presentation
Drawing 8

Presentation drawing 8: This presentation drawing explains and visualises the cross section of design proposal for a river located in an urban area. Sectional drawings are used as graphic images to visualise the spaces created.

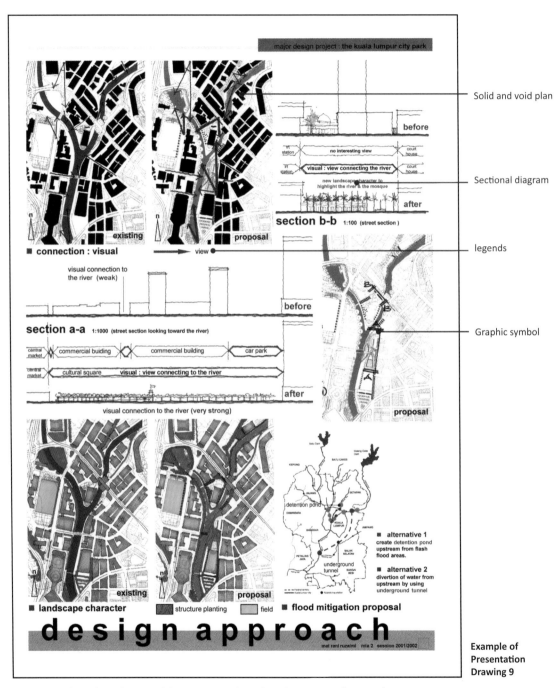

Solid and void plan

Sectional diagram

legends

Graphic symbol

Example of Presentation Drawing 9

Presentation drawing 9: This presentation drawing uses plan and sectional diagrams to explain the connections between urban spaces and a river.

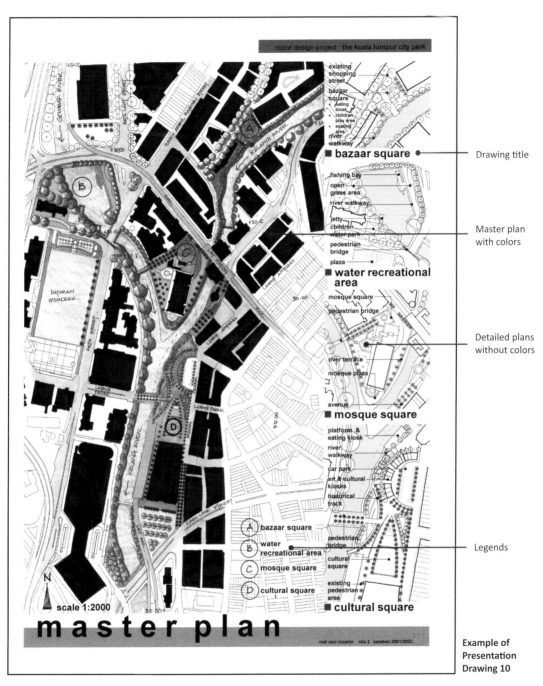

major design project : the kuala lumpur city park

Drawing title

Master plan with colors

Detailed plans without colors

Legends

Example of Presentation Drawing 10

Presentation drawing 10: Colours are used to highlight the main graphic image which is the master plan. Smaller plans without colour are used to highlight activity zones. Legends are used to inform about the location of each zone in the master plan connect these zones to a more detailed plan.

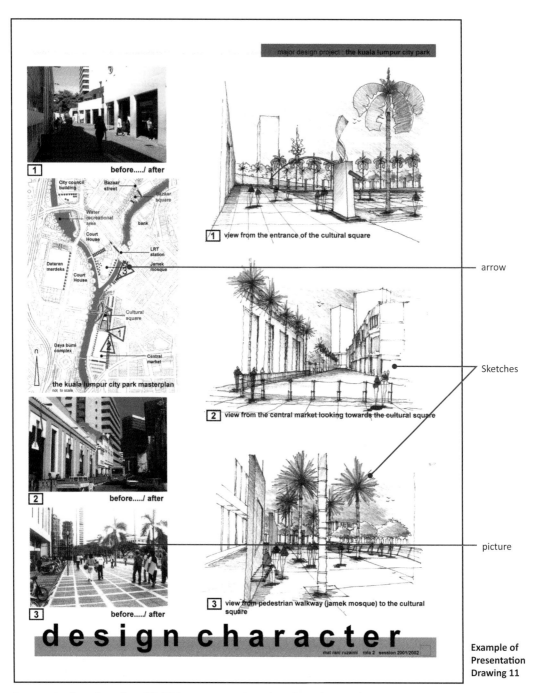

arrow

Sketches

picture

Example of Presentation Drawing 11

Presentation drawing 11: This presentation drawing shows the development proposal of urban spaces using pictures and sketches. Pictures show the existing conditions of the areas, while sketches visualise the proposed design ideas of the areas. Arrows with numbers inform about the locations and directions of the pictures.

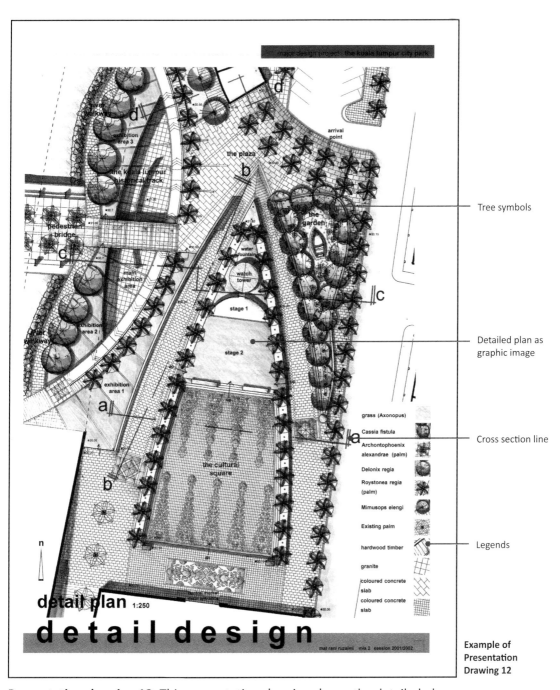

Tree symbols

Detailed plan as graphic image

Cross section line

Legends

Example of Presentation Drawing 12

Presentation drawing 12: This presentation drawing shows the detailed plan of a site in an urban area. A detailed plan of an appropriate scale is used as a graphic image. Appropriate lettering size and font are used for the drawing titles and legends. There are also other graphic symbols, such as the north-pointing arrow, section lines, and tree symbols.

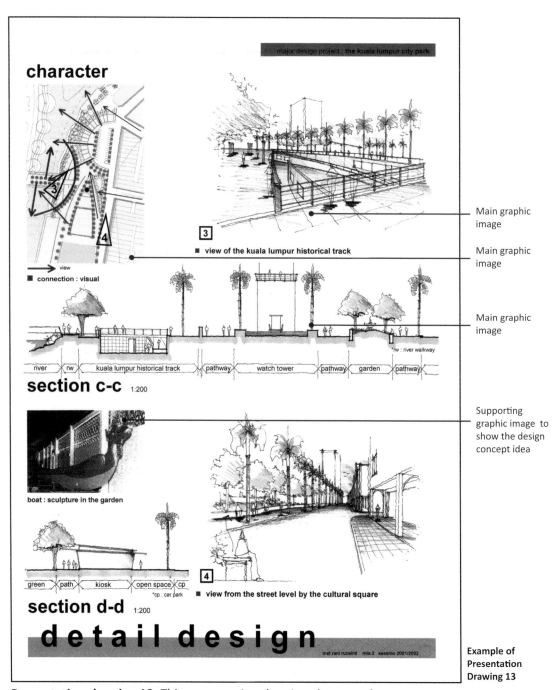

character

major design project : the kuala lumpur city park

3
■ view of the kuala lumpur historical track

→ view
■ connection : visual

*rw : river walkway

| river | rw | kuala lumpur historical track | pathway | watch tower | pathway | garden | pathway |

section c-c 1:200

boat : sculpture in the garden

| green | path | kiosk | open space | cp |
*cp : car park

4
■ view from the street level by the cultural square

section d-d 1:200

d e t a i l d e s i g n

mat rani ruzaimi mla 2 session 2001/2002

Main graphic image

Main graphic image

Main graphic image

Supporting graphic image to show the design concept idea

Example of Presentation Drawing 13

Presentation drawing 13: This presentation drawing shows and visualises the design proposal of a site in an urban area. The arrangement of the graphic images is based on the hierarchy of their functions in the overall presentation drawing composition.

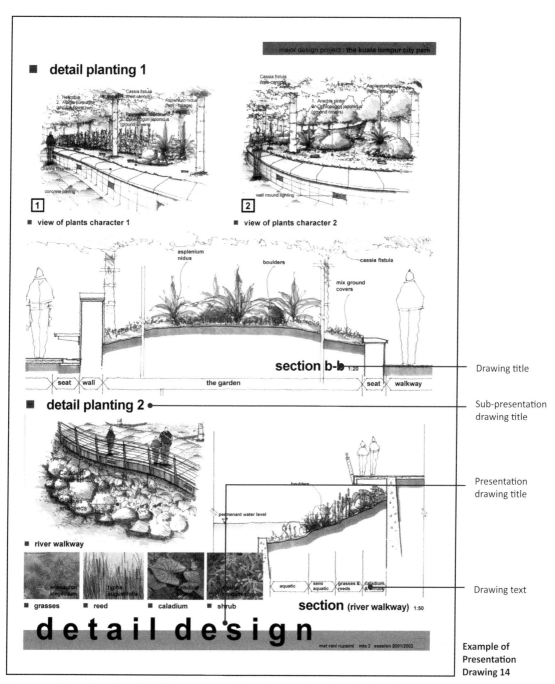

Labels on the drawing (right margin):
- Drawing title
- Sub-presentation drawing title
- Presentation drawing title
- Drawing text
- Example of Presentation Drawing 14

Presentation drawing 14: This presentation shows the detailed landscape design of a site. The typographies in this presentation are based on the hierarchy of their function.

References

1. Ruzaimi,M.R.,& Ezihaslinda,N., *Sketching Basics: One Point Perspective*, Page One, Singopore,2012.
2. Ruzaimi,M.R.,& Ezihaslinda,N., *Sketching Masterclass*, Page One, Singopore,2010.
3. Ruzaimi,M.R.,& Ezihaslinda,N. *Drawing Masterclass*, Page One, Singapore, 2010.
4. Ruzaimi, M.R., *Perspective Creative 02*, Two Point Perspective, Singapore, 2012.
5. Ruzaimi, M.R., *Perspective Creative 01*, One Point Perspective, Singapore, 2011.
6. Ruzaimi, M.R., *The Sacred Garden, Exploration of Garden Design Through Mind Composition*, Pelanduk Publication, Kuala Lumpur, 2003.
7. Ruzaimi, M.R., *How to draw using a box*, Blurb Inc.,2008
8. Robert W.G, *Perspective From Basic to Creative*, Thames & Hudson, 2006.
9. Francis D.K, Ching, *A Visual Dictionary of Architecture*, John Wiley & Sons. Inc, 1997.
10. Francis D.K, Ching, & Corky B., *Interior Design Illustrated*, John Wiley & Sons. Inc, 2005.
11. Francis D.K, Ching, & Steven P.J., *Design Drawing*, John Wiley & Sons. Inc, 1998.
12. Mike W. Lin, *Drawing and Designing With Confidence*, A Step by Step Guide, John Wiley & Sons. Inc, 1993.
13. Angela Gair, *The Artist's Handbook*, A Step by Step Guide to Drawing, Watercolor and Oil Painting, Abbeydale Press,1998.
14. Kingsley K. Wu, *Freehand sketching in the architectural Environment* ,Van Nostrand Reinhold, 1990.
15. Paul Taggart ,*Art techniques from pencil to paint*, Sterling, 2003.
16. Paul Laseau, *Graphic thinking for architects and designers*, Van Nostrand Reinhold, 1989
17. David Sibbet, *Visual Meetings: How Graphics, Sticky Notes & idea Mapping can transform Group Productivity*, John Wiley and Sons.Inc., New Jersey, 2010.
18. Koos E & Roseline, S., *Sketching: Drawing techniques for product designers*, Page One, Singapore, 2008.
19. Michael, E.D., *Color Drawing, Design drawing skills and techniques for Architects*, Landscape Architects and Interior Designers, John Wiley & Sons. Inc.1999.

AUTHOR

Dr. Ruzaimi Mat Rani, a prolific writer who has produced a number of books on sketching and drawing which includes the popular Sketching Masterclass (published by Page One), has been teaching design and graphics communication in design schools for many years. He holds a Doctor of Philosophy (Creative Multimedia) degree from Multimedia University Malaysia (MMU) and a Master of Landscape Architecture degree from the Edinburgh College of Art (ECA), Heriot-Watt University. Prior to that, he obtained his Bachelor Degree of Architecture from Universiti Teknologi Malaysia (UTM).

During his studies in Edinburgh (2000-2002), he successfully sketched a collection of 500 pieces of urban sceneries of the Edinburgh old town, Scotland. This collection became one of his most important artworks. His deep passion in sketching, drawing and painting started during his early years in Sekolah Rendah Tengku Bariah, Kuala Terengganu, his primary school. This later continued when he completed his secondary education at The Malay College Kuala Kangsar. This deep interest accompanied him in his subsequent higher education as well. His artworks have been exhibited in Bakat Muda Sezaman and PNB Art Exhibition.

CO-AUTHORS

Abdul Rahman Rejab is a senior lecturer at the department of Architecture & Environmental Design(AED), International Islamic University Malaysia in Kuala Lumpur. He is an experienced lecturer who has taught Graphic Communication for 10 years at the Centre. He studied Arts at MARA Junior Science College for his A-Levels and then pursued his Bachelor of Arts in Architecture at University of Sheffield United Kingdom. In 2010, he obtained his Master Degree in Heritage Studies and Conservation Management at University Technology MARA Shah Alam. Besides lecturing, he is also a freelance illustrator who provides illustration services for housing developers, architects, interior designers and landscape architects.

Normadiah Kamal is a senior lecturer at the department of Architecture & Environmental Design(AED),Centre for Foundation Studies, International Islamic University Malaysia. She joined the department in 1997 when it took its first batch of architecture students. She became the Course Coordinator, and then the Head of department for the next 10 consecutive years. Her post gave her invaluable experience in the formulation of course curriculum and syllabuses for design courses for foundation years. Apart from managing the department, she also teaches design and graphic communication studios until today. Her A levels Art which she took in Wales, United Kingdom and her early architecture years at the Architectural Association School of Architecture, London, contribute to her knowledge in design and graphic presentation techniques. She also holds a Masters degree in Construction Management.

Dr. Rashidi Othman is an Assistant Professor in the Landscape Architecture Department, Kulliyyah of Architecture and Environmental Design (KAED), International Islamic University Malaysia, Kuala Lumpur. He has vast experience in landscape design and ecology and has been in these fields for many years. He is one of the authors of LAMAN 101 : 101, a garden design book for terrace houses. He also has professional experience as a horticulturist and in landscape ecology. Dr. Rashidi is also a member of The New Zealand Institute of Agricultural & Horticultural Science (NZIAHS) and International Association of Landscape Ecology (IALE).

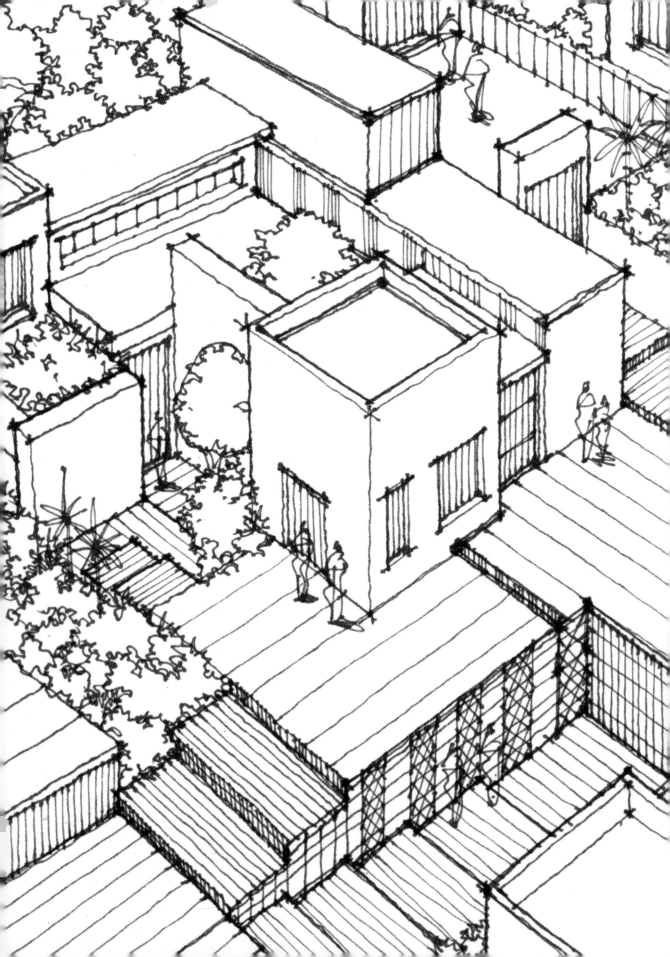